CW00505350

NOTTINGHAM PUBS

DAVE MOONEY

AMBERLEY

To Sarah and Eleanor, with love.

First published 2019

Amberley Publishing
The Hill, Stroud
Gloucestershire, GL5 4EP

www.amberley-books.com

Copyright © Dave Mooney, 2019
Maps contain Ornance Survey data.
Crown Copyright and database right, 2019

The right of Dave Mooney to be identified as
the Author of this work has been asserted in
accordance with the Copyrights, Designs and
Patents Act 1988.

ISBN 978 1 4456 8455 0 (print)
ISBN 978 1 4456 8456 7 (ebook)

All rights reserved. No part of this book may be
reprinted or reproduced or utilised in any form
or by any electronic, mechanical or other means,
now known or hereafter invented, including
photocopying and recording, or in any information
storage or retrieval system, without the permission
in writing from the Publishers.

British Library Cataloguing in Publication Data.
A catalogue record for this book is available from
the British Library.

Typesetting by Aura Technology and Software
Services, India. Printed in the UK.

Contents

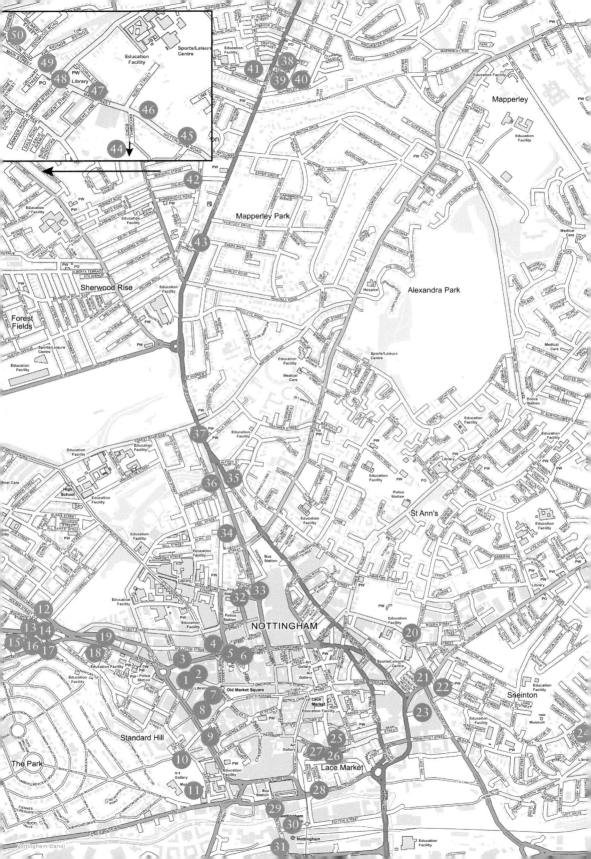

Key

1. The Dragon
2. The Barrel Drop
3. The Tap 'n' Tumbler
4. Yarn
5. Langtry's
6. The Hop Merchant
7. The Bell Inn
8. The Malt Cross
9. Ye Olde Salutation Inn
10. The Castle
11. Ye Olde Trip to Jerusalem
12. The Running Horse
13. The Organ Grinder
14. The Over Draught
15. The Falcon
16. The Sir John Borlase Warren
17. The Dog & Thief
18. The Hand in Heart
19. A Room With a Brew
20. The Bath Inn
21. The Fox & Grapes
22. The New Castle
23. The King Billy
24. The Lord Nelson
25. Kean's Head

26. The Cock a Hoop
27. The Lacemaker's Arms
28. The Newshouse
29. The Barley Twist
30. BeerHeadZ
31. The Vat and Fiddle
32. The Peacock
33. The Rose of England
34. The Golden Fleece
35. The Nags Head
36. The Lincolnshire Poacher
37. The Forest Tavern/The Maze
38. The Pillar Box
39. The Robin Hood
40. Finn Bars
41. Kraft Werks
42. The Gladstone
43. The Doctor's Orders
44. The White Lion
45. The Stag Inn
46. Roots
47. The Lord Clyde
48. The Gate Inn
49. The Cricketers Rest
50. The Nelson & Railway

Introduction

Using the water that is filtered through the sandstone upon which the city is built, Nottingham's brewers have historically produced some of the finest beers in the country. Until relatively recently the city and much of the surrounding area were dominated by three brewing giants – Kimberley Ales, Home Ales and Shipstone's. Their vast premises still stand as a testament to Nottingham's drinking past.

In the wake of these felled giants, a whole wave of new microbreweries have sprung up, often utilizing expertise derived from the defunct firms and creating award-winning tipples that are a credit to the city's past.

Not surprisingly, given the quality of the beer, the city is home to a wealth of very fine pubs – including one that claims to be the oldest in Britain. In this book, I have set out a selection of little walks around some of the best and most interesting of them – from medieval drinking houses, old coaching inns, Victorian music halls and backstreet boozers, to the new crop of micropubs and purveyors of craft beers. Along the way, I have taken the time to look at some of the sights that are passed by on the walks, giving something of the history and character of the city. This is by no means an exhaustive list and there are many fine watering holes that I have been forced to leave out for sake of space. So come with me now for a pint (or five) as we go in search of some Nottingham ale.

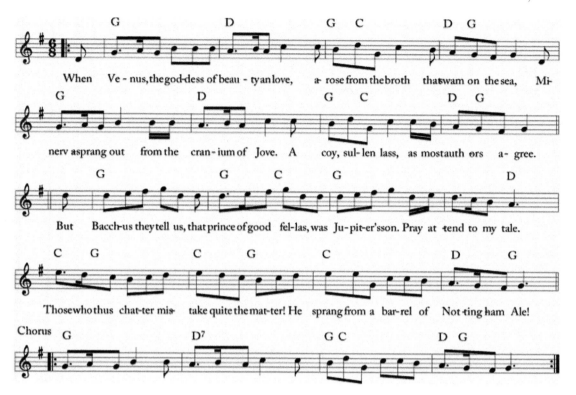

When Ve-nus, the god-dess of beau-ty an love, a-rose from the broth that swam on the sea, Mi-nerv a sprang out from the cran-ium of Jove. A coy, sul-len lass, as most auth ors a-gree.

But Bacch-us they tell us, that prince of good fel-las, was Ju-pit-er's son. Pray at-tend to my tale.

Those who thus chat-ter mis- take quite the mat-ter! He sprang from a bar-rel of Not-ting ham Ale!

Nottingham Ale

Fair Venus, the goddess of beauty and love
Arose from the froth which swam on the sea
Minerva leapt out of the cranium of Jove
A coy, sullen slut, as most authors agree
Bold Bacchus, they tell us, the prince of good fellas
Was a natural son, pray attend to my tale
Those that thus chatter, mistake quite the matter
He sprang from a barrel of Nottingham Ale!

Chorus

Nottingham Ale, boys, Nottingham Ale
No liquor on earth is like Nottingham Ale!
Nottingham Ale, boys, Nottingham Ale
No liquor on earth like Nottingham Ale!

And having survey'd well the cask whence he sprung
For want of more liquor, low spirited grew
He mounted astride to the jolly cask clung

And away to the gods and the goddess flew
But when he look'd down and saw the fair town
To pay it due honours, not likely to fail
He swore that on earth 'twas the town of his birth
And the best - and no liquor like Nottingham ale

Chorus

Ye bishops and deacons, priests, curates and vicars
When once you have tasted, you'll own it is true
That Nottingham Ale, it's the best of all liquors
And who understands the good creature like you
It expels every vapour, saves pen, ink and paper
And when you're disposed from the pulpit to rail
T'will open your throats, you may preach without notes
When inspired with a bumper of Nottingham Ale

Chorus

Ye doctors who more execution have done
With powder and bolus, with potion and pill
Than hangman with halter, or soldier with gun
Than miser with famine, a lawyer with quill
To dispatch us the quicker, you forbid us malt liquor
Till our bodies consume and our faces grow pale
But mind it what pleases and cures all diseases
Is a comfortable dose of good Nottingham Ale

Chorus

Ye poets, who brag of the Helicon brook
The nectar of gods, and the juice of the vine
You say none can write well, except they invoke
The friendly assistance of one of the nine
Hers liquor surpasses the stream of Parnassus
The nectar Ambrosia, on which gods regale
Experience will show it, nought makes a good poet
Like quantum sufficit of Nottingham ale

Chorus

I

Around Town

As with most cities in the UK, the centre is where it's at. In the daytime, there is the hustle and bustle provided by work and retail; in the evening the town is alive with bars and restaurants. With two major theatres, two universities and one of the nation's leading rock venues (Rock City), Nottingham is an active social hub. From a cheeky lunch hour snifter to a quick one before the panto, this chapter contains the pick of the crop from around the city centre.

Starting on Angel Row, facing away from the Old Market Square and the Council House, walk along the right-hand side of the road, passing a Yates Wine Lodge and a number of shops. You will eventually come to our first pub, The Dragon

1. The Dragon

It seems odd that anywhere so close to the town centre could ever be described as a hidden gem, but the narrow, attractively fronted Dragon is often skipped over when people are 'doing' Nottingham. This is a shame as it is a pub with a lot to offer.

Long and thin, it writhes sinuously, like the mythical wyrm after which it is named, from the quiet seating area at the front, through a lively bar area and out into the patio at the back. These are all pleasant enough, as is the home-cooked food (large portions) and real ales that are on offer. The true joys of this pub, however, are to be found in the music and other activities that it provides.

Thursday to Saturday evenings are vinyl DJ nights, with particular mention going to the man who provides music on alternate Thursdays. He plays an eclectic range that covers most of the last hundred years, and usually leaves the punter with some obscure earworm or other to go away and look up. The DJ nights are popular, convivial and generally result in people dancing on the tables (indeed, one of the barmen was lucky enough to find love while gyrating off ground – a long-term romance that has recently led to them setting up home together).

If music is not your thing, then The Dragon has something a bit sportier out the back. In a small outhouse, just off the patio, is a Scalextric set. Bear with me. This is not the little circuit that your dad pretended was actually for you when you were a

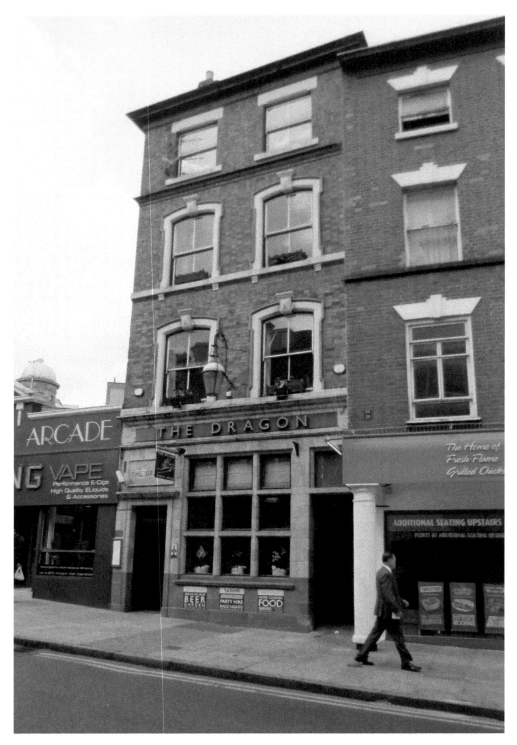

The Dragon, viewed from the street.

The Dragon viewed from a much smaller street!

kid. No, this is a huge, looping track, with screens mounted on the walls that follow the race. Around the course are an army of toy spectators. Recognise the buildings? It's the area around Nottingham's Old Market Square and Angel Row. Look – there's The Dragon in miniature!

Tuesday night is Scalextric night (a snip at just £5), although it is also available for private hire, should you fancy an evening spent racing around our tiny city.

Exit the pub and turn left to retrace your steps. After a few hundred yards, you will pass a narrow alleyway ('jitty' in the local dialect) immediately next to the entrance to a kebab, pizza and fried chicken shop. The shop's sign overhangs the alley, but under this there is a smaller sign that reads 'Hurt's Yard'. Go up here and you will find the next pub near the top.

2. The Barrel Drop

With its bulging, small-paned windows – like something out of a Dickensian Christmas card – and tucked away at the narrow end of an alley, the Barrel Drop provides a rather romantic welcome.

Initially an independent micropub, it has since been acquired by the Magpie Brewery. This has allowed it to expand its range of beers to include five hand pulls, seven craft kegs and an unfathomable number of bottles.

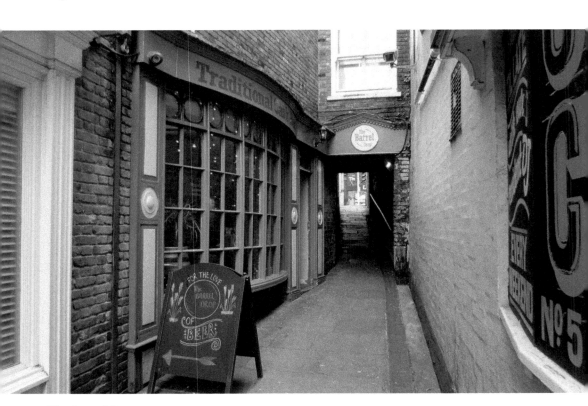

The Barrel Drop.

Inside the Barrel Drop.

It is, being a micropub, a small and intimate affair – perfect for a chat or a game of chess. 'Board Game and Beer' evenings are a regular thing, with plenty of each to be going at. Games range from modern creations to traditional favourites, allowing you the scope to either laugh like a drain at your inability to balance straws or to reflectively beat a friend at draughts. No one has yet shown enough commitment to dedicate themselves to an entire evening of Monopoly, however, and the box grows dusty on the shelf.

Occasionally live music is provided by one of the barmen – Elliot – who leaps between his guitar and the bar to serve any customer willing to interrupt his songs in the interest of getting another pint.

Being a Magpie pub, their beer is prominent and one is able to purchase an attractively presented gift box containing four beers of your choosing (or three and a glass if you prefer).

Exit the pub and turn left to exit the alleyway out onto Upper Parliament Street. There is a crossing near to the alley's exit. Use this and then turn left to follow the main road. Take the next right up a pedestrianised street called Parliament Terrace. The next pub is at the top of this street, on your right.

3. The Tap 'n' Tumbler

The nearby Rock City is one of the UK's leading rock venues, hosting a huge range of internationally renowned acts, as well as club nights. The uninitiated may ask, 'Where does one go to wind down post-gig or to preload on affordable beer before being forced to sup the overpriced (and, frankly disgusting) ale on offer at City?' Well, one usually goes to the Tap 'n' Tumbler.

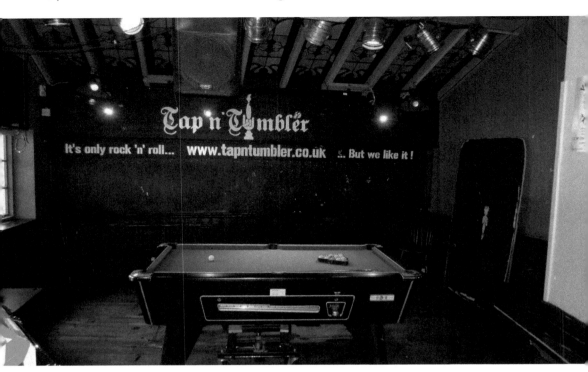

The pub's motto, The Tap 'n' Tumbler.

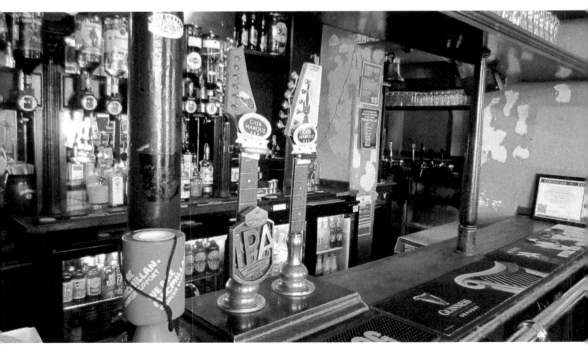

Guitar neck hand-pulls, The Tap 'n' Tumbler.

The pub has the slightly sleazy atmosphere common to all rock bars. The clientele generally range from student rockers to hairy old bikers – mostly dressed in black. Leather, skulls and tattoo sleeves are a sartorial must. The walls are black and images of a, surprisingly varied, pantheon of rock stars peer at you from the gloom – I blushed under the gaze of David Bowie, Siouxsie Sioux and Lemmy.

The tables are interesting – inlaid, as they are, with old vinyl records. Two of the pumps on the bar are made from electric guitar necks, which looks cool, but is apparently rather inconvenient for the bar staff. At one end of the U-shaped pub there sits a well-used pool table. This is moved aside at weekends to allow for room for live bands – rock covers on a Friday and Saturday, unsigned originals on a Thursday. The music is fairly diverse, all things considered, with only 99 per cent of it being heavy metal. Sometimes they change gear, just to mix things up a bit, and mellow out with a bit of hard rock. There is a sign on the outside wall, advertising an open mic night: 'No backing tracks. No loop-boxes.' I approve.

Exit The Tap 'n' Tumbler by the front door and turn right. Continue to the end of the road, where you will see a tram stop. The Theatre Royal stands across the road, directly in front of you. Cross the road and walk along the front of the theatre. Turn left to walk along the side of the building. It is here that you will find Yarn.

4. Yarn

Also known as the Yarn Bar, due to some confusion with the online branding, this is a large, very modern-looking establishment that runs along the side of the theatre. There is a rooftop terrace with views of, well, the congested heart of the city, but that's not the point!

Yarn.

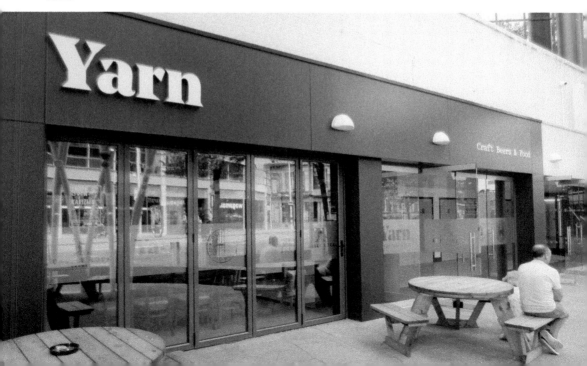

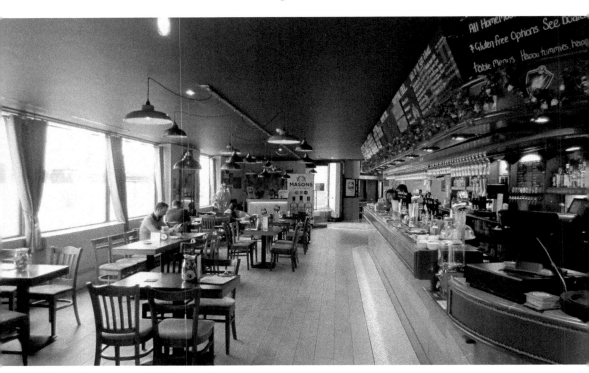

Inside Yarn.

Yarn was opened in November 2017 as a partnership between Castle Rock Brewery and CGC Event Caterers, as a sort of halfway house between theatre bar and regular pub. It offers refreshments for theatre goers (indeed, it is at its busiest before shows and during the intervals), but, unusually, it also keeps regular pub hours and is open for passing trade.

The long, shiny bar serves a wide variety of drinks, including ten craft beers, eight real ales, and two ciders. They also specialise in gin with an occasional 'pop-up' Mason's gin bar and gin tasting evenings. They also claim to be the only Castle Rock pub to sell an alcohol-free version of the spirit. This 'botanical' drink is made from English herbs, hay and peas. It has a faint whiff of the wholefood shop about it. 'You can certainly smell the peas!' I beamed at the barman as he wafted the bottle under my nose.

In terms of food, Yarn offers a trendy selection of tapas and hand-rolled pizzas, with a large selection of vegan and gluten-free options. Their 'free from' range even extends to the beer (which is always good to know if you don't want your drink to have been strained through fish guts).

Of most interest to me is Yarn's position as a live music venue. I always associate Sunday afternoons with jazz, and this is the latest of a number of places in Nottingham to hold gigs on the Sabbath.

Exit the Yarn Bar and turn right to retrace your steps. You will soon come to a pelican crossing. Use this to cross over to a large, glass-fronted cinema and restaurant complex. To the right of this is our next pub.

5. Langtry's

With a large outside seating area, on the pedestrianised thoroughfare between the pub and the cinema complex, Langtry's is the perfect place to sit and relax on a hot, sunny afternoon. Generally speaking, it tends to attract an older crowd. The students obviously haven't cottoned on to the various cheap drink offers: real ale £2.75 per pint on Mondays, happy hours from 11–5 the rest of the week, cheap bottles of Prosecco before 8 p.m. on Fridays. Strange, given its proximity to the university, but then they're probably too busy studying.

The pub does, however, benefit from being close to the theatre. A lot of people pop in on their way to or from a show. Customers are given a 10 per cent discount if they show their theatre tickets, and there is always the chance of bumping into a celebrity. Your humble author was lucky enough to have his own brush with fame there. My friend Nicki and I were walking past Langtry's one afternoon when I spotted a familiar face, sipping at a pint by the side door. He was with a gaggle of other men. 'That bloke looked just like Mark Chadwick,' I told Nicki. We looked back to see not just Mr Chadwick, but all of The Levellers smiling at us and holding up their pint glasses in greeting. They were due to play Rock City that evening, as part of a 'Levelling the Land' anniversary tour and were, presumably, quite chuffed to have been recognised.

Exit Langtry's by the door closest to the road and turn left. The very next building, right on the corner, is The Hop Merchant.

A legend looks down on the punters, Langtry's.

Inside Langtry's.

6. The Hop Merchant

Formally The Turf Tavern, The Hop Merchant is a tiny little pub on the corner of two busy main roads. So small is it that it looks as though it may have been borrowed from the models that surround The Dragon's Scalextric.

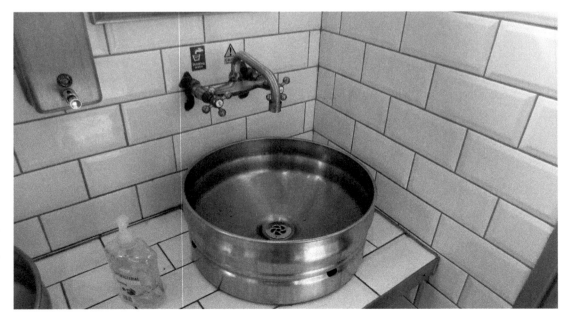

Photogenic sinks at The Hop Merchant.

The first thing that you are likely to notice are the ends of beer kegs that decorate one wall (a motif that has spilled over into the gents, where half kegs are used as sinks. This is the only pub in the book that has had toilets worthy of being photographed).

This is definitely a beer pub with a great selection of real ales and a growing range of craft beers (space allowing). Like its neighbour, this is not really on the student circuit, so the clientele tend to be a little older and a little more relaxed.

The size of the pub tends to shape its character. There is live music every Friday, though the lack of room means that this is an acoustic solo act doing covers. Similarly, the small kitchen only allows them to do light snacks – sandwiches and the like – with a few simple pub staples.

Also, like Langtry's, The Hop Merchant gets plenty of overspill from the theatre. Actors from the shows tend to come in towards the end of their run.

'Who's the most famous person that's ever come in?' I asked, in wide-eyed expectation.

'Matthew Kelly's son!'

'Wow! How did you know it was Matthew Kelly's son?'

'He looked just like him!'

A-listers aside, the true lure of this pub is in its upstairs snug. Like the rest of the pub, it is on the small side – lovingly furnished and cosy to the extreme – but is quiet and welcoming. A perfect place to sit back and relax, or look out of the window onto the hustle and bustle of the city centre.

A delightful upstairs snug, The Hop Merchant.

2

The History Walk

There are three pubs of extreme age in Nottingham, each vying for the position of most ancient. The subject has become quite heated, especially as one of the pubs capitalises on its claim to being the oldest pub in the country.

Starting at the point where Angel Row, Beast Market Hill and Long Row meet, you should have Nottingham's Old Market Square in front of you. This is the largest surviving city square in the United Kingdom. Beyond it you will see the grand neoclassical Council House, with its distinctive dome. To your right, you should plainly see The Bell Inn.

7. The Bell Inn

Upon entering The Bell you will see, to your left, an interior stained-glass window giving the date of the pub as circa 1437. The rooms on either side of this narrow entranceway represent the oldest parts of the building – the Tudor Bar and the Elizabethan Bar.

At the end of the corridor you will find the 'Snack Bar'. This is the main room, with a stage area, plenty of room for diners, and a long bar that bulges oddly at one end. This bulge allows customers to gaze through glass a porthole down a thirteenth-century well. At the bottom of this are the cellars. These are two levels deep and once belonged to a guesthouse associated with a Carmelite monastery that used to stand on nearby Friar Lane.

For me, The Bell has always been associated with one thing – jazz. The Footwarmers have been playing their raucous, trad-jazz sessions on Sunday afternoons in the Snack Bar for as long as I can remember. I recall watching them one Sunday afternoon long ago with my then-girlfriend. We got chatting to an elderly man who was dressed as a 1940s spiv. He waited until my girlfriend had gone to the toilet to surreptitiously show me his secret collection, namely a stash of saucy seaside postcards that he had hidden in his jacket.

There is a rotation of four different jazz bands, including one comprised of young bloods from the university, who play on Monday evenings, as well as Wednesday night open mic and live music on a Friday. This is a great music venue right in the city centre.

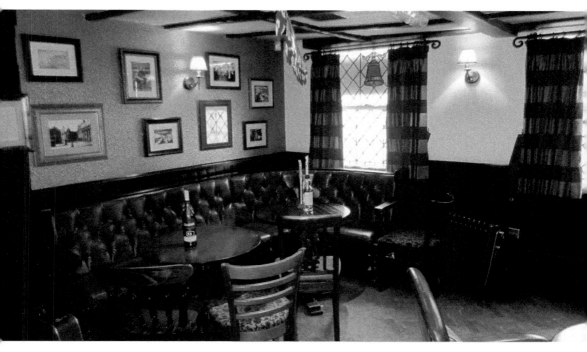

Lizzie's Bar, the Bell Inn.

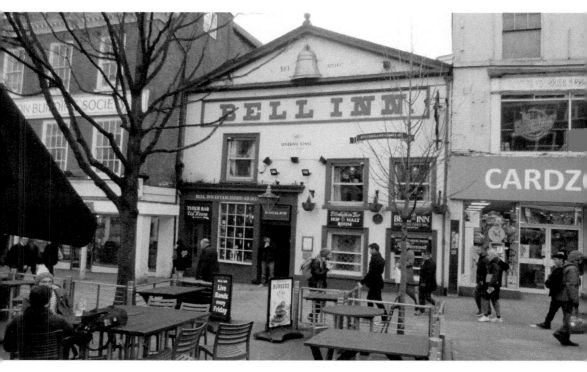

The oldest pub? The Bell Inn.

You can also eat here if you wish. There is a regular pub menu, as well as Sunday roasts and special fish and chip offers on 'Fishy Friday'.

Should you come for a drink here during the summer, there is an outside area where you can sit and chat. However, this is at the front of the pub and requires you to cross a few feet of pavement to get to it. As local bye-laws forbid on-street drinking, a member of staff will need to be on hand to carry your pint over for you. Woe betide anyone who tries to carry their own pint; the full weight of the law will be upon them.

I asked the manager how he felt about the various competing claims for the title of oldest pub. The Bell and the Trip are both Greene King pubs, and they support each other and give mutual recommendations to customers. The managers even drink together at team socials. We shall see, in time, how the landlord of the third of the competing pubs feels about the matter.

Upon exiting The Bell Inn, turn right up St James' Street. After a few hundred yards you will come to the Malt Cross.

8. The Malt Cross

Is the Malt Cross a pub? Well, no, not exactly.

As soon as you enter the building you are confronted by a wide, open space and the gorgeously decorated metal supports for an upper horseshoe-shaped gallery. Overhead, there is a magnificent arched roof (rumour has it that it is held together solely by glue), while before you, looking down over the lower floor, is a stage. This is clearly the focal point of the room and the reason for its existence. This is – or rather was – a music hall.

One of the few remaining examples of the gaudy variety houses of Victorian England, the Malt Cross still regards itself as an entertainment venue.

The Malt Cross.

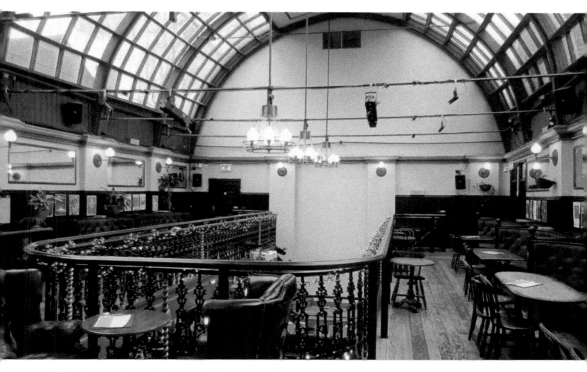

All held together with glue!? The Malt Cross.

Affiliated with local Christian churches and keen to do good works, this is a place with a moral imperative: namely to provide an alternative to the binge-drinking excesses of most modern city centres. A place where music and the arts can flourish.

There are regular and varied performances held upon the stage and a not-for-profit workshop and exhibition space for local artists situated below ground. This is also the home of the Nottingham Street Pastors, who can be seen around the town of a weekend administering help to the needy. All very wholesome. This is ironic when you consider that the place lost its entertainment licence in the early twentieth century after garnering a rather seedy reputation – a charge often levelled against the bawdy music halls of the day.

The Malt Cross serves a wide variety of hot and cold drinks, as well as some rather excellent food. Its most charming provision for me, however, is the 'Beer and Carols' event that is held every December. It has gained such a reputation in the city that the lengthy queues begin forming in the freezing festive air, hours in advance. Patrons are then treated to a rowdy, slightly drunken, evening of yelling their way through a deep stocking's worth of Yuletide favourites. Is there anything quite so Christmassy as grown adults, pint glasses in hand, frantically yelling out requests for 'God Rest Ye Merry Gentlemen' and 'Away in a Manger'. Be prepared to leave with a sore throat!

After leaving the Malt Cross, continue on to the end of St James' Street. Turn left here and walk down Maid Marion Way for approximately two minutes to reach the next pub.

9. Ye Olde Salutation Inn

For the landlord of the 'Sal', there is no debate to be had over which is Nottingham's (and by extension the nation's) oldest pub. Approach him on the subject and he will tell you – in passionate detail – why he thinks the Trip's claims are entirely false and why The Bell is only the second oldest in the city. Parts of the Salutation date back to the thirteenth century, and there is scientific evidence (the dating of some of the wooden beams) to prove it.

You may be very surprised by this if, having followed the directions given to you in this book, you have arrived at what appears to be a fairly uninspiring mid-twentieth-century building. The truth of the matter is that this part of the city was probably the worst affected by the wave of civic vandalism that swept the country in the decades following the Second World War. Just look around you before entering the pub and you will see what I mean.

Most of what now comprises the Salutation was built in the late 1950s around the much earlier rooms that still stand on either side of the entrance that faces away from Maid Marion Way. These rooms are cosy, snug and obviously of great antiquity. The oldest of these – to the left as you approach from the main bar – dates from around 1240. Discounting the Trip's claims and aware that The Bell has been rebuilt, this date leads the landlord to believe that he runs the oldest establishment.

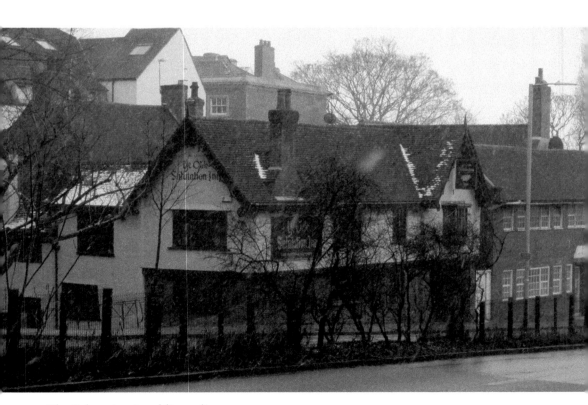

The Salutation in a blizzard!

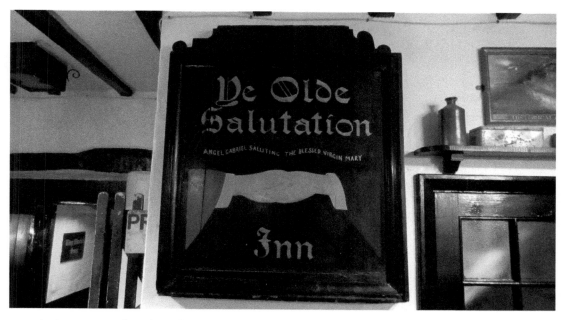

A vintage sign for The Salutation.

So, that all seems pretty cut and dried, doesn't it? Well, not exactly. Despite the landlord's claims, historians argue that the oldest part of the building was actually built as a tannery, workshop and living quarters. It was, they say, built on the site of an earlier alehouse – the wonderfully named The Archangel Gabriel Salutes the Virgin Mary (shortened to the Salutation) – but was not itself a pub. The landlord disagrees with this. He doesn't believe that it was big enough to be a home and claims a continuous usage from the time of the original 'Sal'. The controversy rumbles on.

Even if its age isn't enough to secure the pub's place in the record books, the landlord lays claim to another title – the most haunted pub in England. At the last count, he assured me, there were eighty-nine apparitions to be met with in the Salutation. This means that on quiet nights the dead outnumber the living.

As with many pubs in Nottingham, the Salutation sits on top of some man-made caves. You are welcome to go and see them, provided that the pub is not too busy and someone is available to take you down. These, the landlord informed, have been dated to around 400 AD (other sources date them at the ninth century, which is still pretty old!) and were, at one time, used as a Saxon grain store. With all that grain about the place, the landlord finds it inconceivable that they were not brewing.

Its great age aside, the Salutation is most famous in the city for one thing: rock music. This is an old-fashioned rock and bike pub, as you will hear the second that you cross the threshold. Like most rock venues, this is a very friendly and welcoming place to hang out. The beer is good and the food is superb. Oldest or not, this is definitely one of Nottingham's highlights.

Exit the Salutation through the Maid Marion Way entrance and turn right to go up the hill. You will soon come to a pelican crossing. Cross over Maid Marion Way and continue onto Friar Lane. Follow Friar Lane until it opens out into a wide pedestrianised area. You should see a pillar box and, perhaps more strikingly, Nottingham Castle.

There has been a castle on this site since at least the time of the Norman Conquest. Nottingham Castle played a pivotal role in both the Wars of the Roses and the Civil War. In the minds of people the world over, however, it will always be connected with the legend of Robin Hood. It now contains a museum and (when not closed for refurbishment) hosts many events in Nottingham's social calendar, including beer festivals, open-air theatre and medieval tournaments.

Turn left at the pillar box to head down the hill. In front of you, you should see an eye-catching building that now houses a pub called, rather confusingly, The Castle.

10. The Castle

The Castle, which is situated in front of its defensive namesake, is one of the masterworks of famed Nottingham architect Watson Fothergill. The exterior, with its imposing turret and black Tudor-style woodwork, is typical of his style. The windows are leaded with stained-glass depictions from the legends of Robin Hood. These are pretty enough from the outside, but are best appreciated from within, with the afternoon sun beaming through them, giving the whole pub a light and airy feel.

This is a very pleasant pub. During the summer months, tables and chairs are set out along the front, making the most of both the constant sun that its situation receives and the charming views of the castle walls. Its position, of course, makes it a hit with the tourists, but there is also a steady stream of locals. This is a pub that makes real effort to create a friendly, family atmosphere: dogs and children are welcome; parties of rowdy students and football fans are not.

Beautiful stained glass at The Castle.

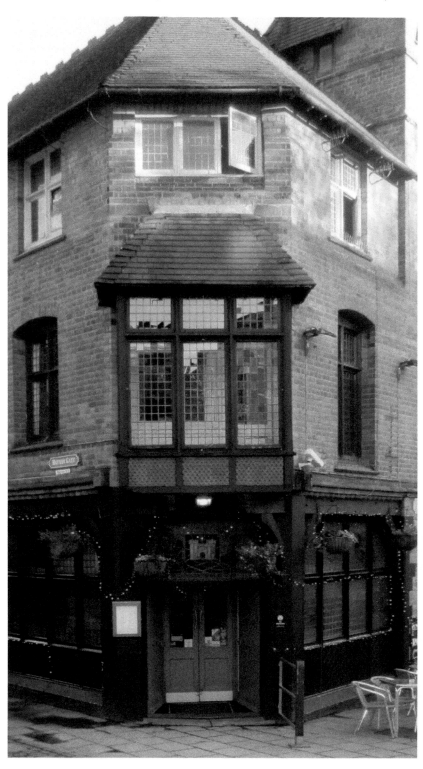

One of
Fothergill's
finest,
The Castle.

On Monday evenings it is wine and wool night – an evening for all budding knitters to get together, drink discounted wine, eat some well-cooked food and create a masterpiece of clothing fit to rival the architectural grandeur of the venue.

Upon leaving The Castle, continue down the hill. On your right, you should see the iconic statue of Robin Hood. This statue has become one of Nottingham's most famous landmarks and, if you haven't seen it before, it is worth taking a few minutes out of your walk to have a look. There are several other statues surrounding it, depicting famous episodes from the legend of Robin Hood. Opposite the statue and a little further down the hill, you should be able to see the Severns Building. This is a rather crooked-looking medieval building, originally built *c.* 1450. Following damage during the Blitz in 1941, and threatened by urban development in the late 1960s, it was rebuilt at its current site in 1970. The place where it originally stood is now a part of Broadmarsh Shopping Centre. Follow the walls of the castle down the hill. As they begin to curve to the right you will be greeted with the pleasant sight of The Trip.

11. Ye Olde Trip to Jerusalem

Well, you've made it. Here is the Trip to Jerusalem. The pub that claims to be the oldest in the country, and it certainly looks the part – rambling aimlessly, set into the walls of the castle that loom over it. It's very easy to picture would-be crusaders taking a final draught of ale here before making their own lengthy trip to the Holy Land. But, as we have seen, appearances can be deceptive.

The pub's setting, hewn into the Castle Rock itself – the very rooms, not just the cellars are cut into the sandstone – seems to put it in a world of myth. True historical figures sit cheek by jowl with Robin Hood and Little John and the other outlaws of Sherwood.

Ye Olde Trip to Jerusalem.

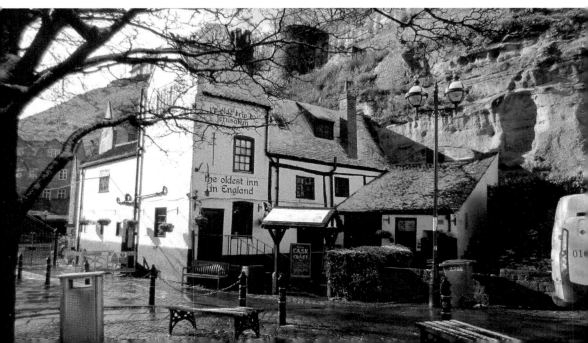

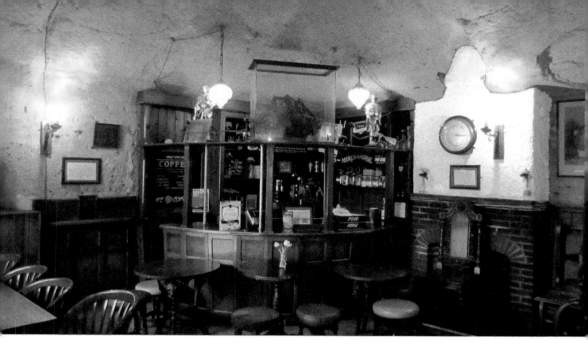

Would you dare to touch the cursed galleon? Ye Olde Trip to Jerusalem.

In the upstairs bar are two, very curious, objects. The first is the 'Pregnancy Chair', said to increase the fertility. The manager was keen to tell me about a family of women – three generations – who have made it a point of visiting the pub shortly after getting married with the express purpose of sitting in the seat.

The second, and perhaps more famous, object is the 'Cursed Galleon'. This is a large, cobweb-covered model of a ship, safely housed within a glass case. Legend has it that anyone foolish enough to touch it will be cursed to die shortly afterwards. There have been accounts of people trying to photograph the galleon, only to have the photographs mysteriously deleted. One man, who had spent several weeks travelling around Europe, lost all of his snaps of the trip, after attempting to get a picture of the boat. I have heard claims from people that have touched it and survived, but the manager is a firm believer – he's never even been tempted. For all of my Renaissance man bravado, I think that I would be wary too.

In one of the rooms that is cut into the rock, there is a curious game that may be unique to the pub. A bull's horn is set in the wall. Near it, a hoop hangs from the ceiling, by way of a long cord. The aim of the game is to swing the hoop and land it on the horn – a feat that is much, much more difficult than it sounds. This game is a great icebreaker – a wonderful way of getting customers (who often come from all over the world) talking to each other. This is aided by the fact that the pub does not have any music playing – a rare treat!

Under the pub are the ubiquitous caves that many of Nottingham's pubs use as cellars. These caves, however, are carved directly into the Castle Rock. I was directed to a part of the cellar that could be shut off with an ancient rusting gate. This, supposedly, was a condemned man's cell – a place of unbearable torment, where a prisoner would

A unique pub game.

be chained to the wall with a manacle and an iron mask placed over his head. A small alcove was said to house the gaoler. All very Alexander Dumas.

A more recent human tragedy can be evidenced from a small military wristband that is fixed round a pipe in the cellar. This belonged to an American GI who had spent a good deal of his leave travelling around Europe. Enamoured with tales of Robin Hood, he had always wanted to visit Nottingham, and took delighted photos of himself in the Trip when he did. Following his leave, he returned to duty in Iraq. Shortly afterwards, he was killed by an IED. His family, having seen the photos of how happy he had been at the Trip, brought his tag there and aim to make it a regular pilgrimage site from their home in the States.

Two other pubs once stood immediately adjacent to the Trip – The Pilgrim and The Hanger's Well (so called for the service that it provided to the denizens of the condemned man's cell). These burnt down in 1909, and the recess in Castle Rock that once housed The Pilgrim was bricked up. Apparently, there is still a room behind the bricks – fire damaged, but otherwise intact. A trapdoor, high in the ceiling of the Trip's cellar is the only way in. It is dangerous and inaccessible to the public. I don't think that I've ever wanted to see something quite so much in my entire life!

So, which of the pubs is the oldest? Well, in 1998 a team of historians from Channel 4's *History Hunters* program looked into it. After a fair amount of digging through the archives they concluded that while the oldest parts of the Salutation represent the most ancient of the buildings, The Bell had been used as a pub for the longest. This brought a big, though modest, smile to the face of The Bell's manager when I mentioned it.

3

Canning Circus

Taking its name from the nineteenth-century prime minister George Canning, traffic-heavy Canning Circus seems an unlikely place to go for a quiet drink. With plenty of student accommodation around, this is a lively area, filled with takeaways and bristling with energy. There are some real gems to be found here, including old-fashioned boozers, new wave micropubs and a place where you can have a pint in a cave.

Our walk starts near the top of Alfreton Road. If you are on the left-hand side of the road, heading into town, you should easily be able to find the green-tiled frontage of our first pub, The Running Horse.

12. The Running Horse

As a teenager in the '90s with an interest in live music, 'The Runner' had almost legendary status. Since the 1970s, the pub had been a Mecca for rock and blues aficionados. Rumour had it that the Stones had played there (they hadn't), and people could still remember seeing such legendary figures as The Groundhogs and John Ottway. The pub's glory days were behind it, however, and by the time I was of drinking age it had begun the slow decline into a shabby and down-at-heel dive. The lead singer of the band that I play with remembers performing there at around this time. In a moment of wild, rock and roll abandon, he leapt into the air, only to find himself falling through the stage, leaving him – like Doctor Foster – submerged up to his middle. Such was the state of neglect and disrepair that the pub had fallen into. It was cold, it was dirty and the beer was undrinkable. Inevitably, it closed. And reopened. And closed again. And reopened. And closed…

For a long time, it seemed that it would never be a going concern. That was until the current landlord – Rob Gibson – took over. He had formally run the, rather successful, Guitar Bar and had plenty of contacts in the music biz. He was also determined to spruce The Runner up and return it to something of its former glory.

And now, it's nice! Its clean and welcoming. There is a lazy, southern states of America vibe to the place, with a stage done up like the kind of porch that you can imagine an old blues man playing his harp, or a good ol' boy in a rocking chair, gently plucking his banjo on. Americana is Rob's passion and the décor reflects this.

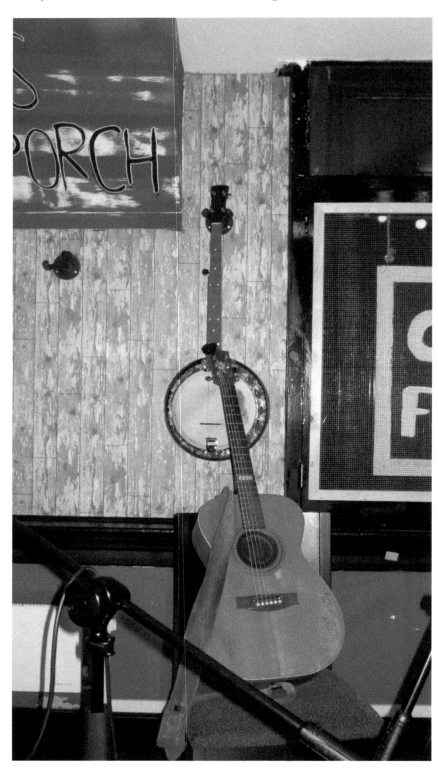

An Americana
starter kit,
The Running
Horse.

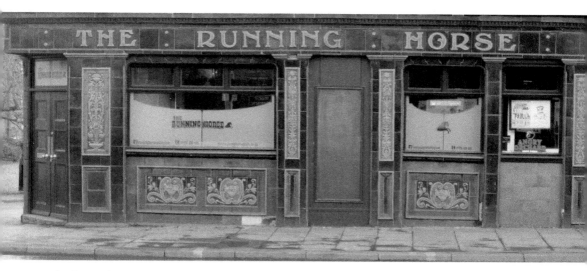

The legendary 'Runner'.

There are also a couple of real ales on and some craft beers in the fridge, but this is not a beer pub. Music is the focus and the drinks are purely a social lubricant.

Rob is quite aware that this is never going to be a hip joint. It's never going to compete with the trendy, hipster bars in places like the Lace Market and Hockley, but the music is great and that is the draw. The challenge now is to get younger people in to see the bands. The average age of a blues audience is about seventy.

On the night that I popped in to see Rob, the place was rammed. Whatever Rob is doing, it seems to be working.

Upon leaving the pub, cross over Alfreton Road (you should see crossings both to the right and left of you). Almost directly opposite the Running Horse, on the other side of the road, you will find The Organ Grinder.

13. The Organ Grinder

The pub sign for The Organ Grinder features the grinning face of a blue chimpanzee – the logo of the Giltbrook-based Blue Monkey brewery. Since launching in 2008, they have acquired four pubs: this one, another in Arnold called The Organ Grinder, a place in Newark named The Organ Grinder, and another in Loughborough that carries the – rather predictable – moniker of The Organ Grinder.

'Why do all your pubs have the same name?'

'It's a branding thing – if you see a pub called The Organ Grinder, you know that it's Blue Monkey!'

This Organ Grinder occupies what was, at one time, The Red Lion. I can remember drinking there years ago, when it was part of the long run of pubs that lined Alfreton Road and formed an established pub crawl into the city centre. Now, with all of the pubs between here and the ring road closed, it vies with The Running Horse for the position of being the first and last pub out of town.

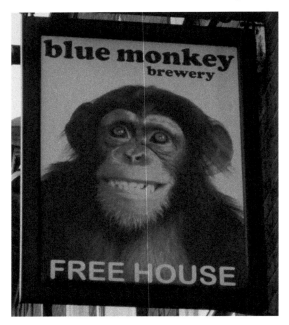

Left: That's not a monkey! The Organ Grinder.

Below: The beer garden The Organ Grinder.

Lots of people start their pub crawls there, and many use it as a finishing point. There are plenty of good restaurants and takeaways around it, so it offers a perfect place to finish a session before grabbing some Turkish snap or a bag of chips.

In terms of regular custom, the pub has a very varied clientele. It is situated in Radford, a traditionally working-class area that has in recent decades attracted a huge student population. It is also close to the, highly exclusive, Park area of the city. This means that students, highly paid professionals and tradesmen all rub shoulders in a venue that prides itself on being a talking and drinking pub. There is also a gallery

nearby, which supplies the place with some arty, bohemian customers. A team of campanologists meet there for a weekly drink, and it is a regular haunt of a group of firemen who give a quick flash of the blue lights every time they drive past.

Should you happen to be passing at early doors on a Friday, all real ales are just £2.50 per pint between 4.30 and 7.30 p.m. There is also regular live music, a real log burner, a beer garden with plenty of beautiful flowers *and* a quiz night every other Monday. The staff also make a point of being massively dog friendly. They provide water and snacks for any pooch who comes in. In the words of the man in charge: 'We'd rather have your dogs than you!'

Exit The Organ Grinder and turn right. In a few seconds, you will come to a large building on the corner – The Over Draught.

14. The Over Draught

One wonders when the fashion developed for naming public houses with a clever pun. Is there somebody, somewhere, whose job it is to come up with them all?

The Over Draught was, as you may have guessed, once a bank (although for many years it was a fancy dress shop). Now it is a large and very spacious ... I almost called it a pub, but actually it aims to straddle two worlds – that of the pub and that of the bar. This is a very studenty area, and The Over Draught obviously aims to capitalise on this, with its ultra-modern, hip vibe and its huge selection of trendy craft beers. Of a weekend, it becomes a bar proper, but on a weekday afternoon it is quiet as the grave – a perfect place for a couple of old boys to sit and chew the fat. Since opening in early 2018, it has become part of the regular crawl into town.

Here, beer is king. 'Craft beers are evolving,' one of the staff told me, 'while a lot of the more established breweries are standing still. They need venues that can showcase

Witty puns at The Over Draught.

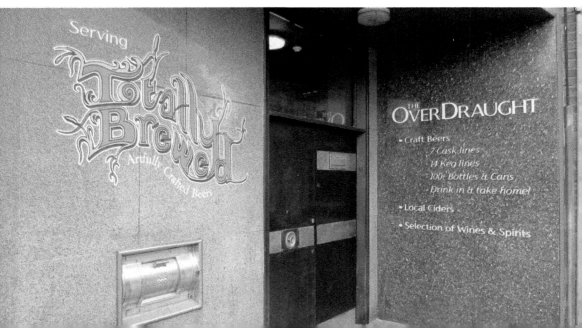

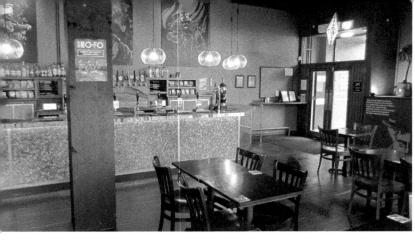

Left: The hip interior of The Over Draught.

Below: Close neighbours, The Falcon and The Sir John Borlase Warren.

their beers in the best way that they can.' He gave me a bit of a mission statement: 'Quality beers, as affordable as we can make them, in a venue that everyone will enjoy.'

Turn right as you exit The Over Draught, then use the pelican crossing at the end of the road to get to the pub that is straight in front of you.

15. The Falcon

At one time a Shipstone's pub (a pub sign bearing their name hangs on the wall in the snug), The Falcon, like so many others in the area, fell into the hands of Punch Taverns. The next bit of the story has become depressingly familiar. It was run into the ground, becoming shabby and disreputable, eventually closing altogether. Fortunately – and it is fortunate, as this is a lovely cosy little pub with plenty of character – it was reopened in 2013 as an independent free house.

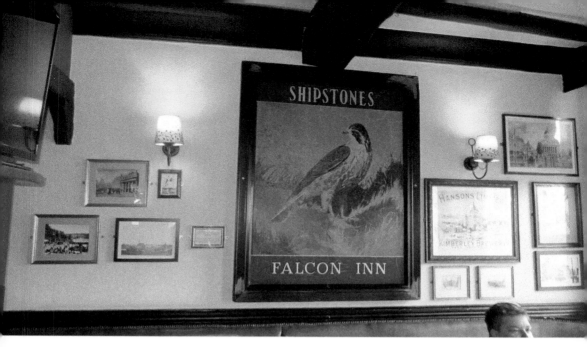

Memories of Nottingham's brewing past, The Falcon.

Attractively bijou, the pub packs a surprising punch for its size, with six real ales and a real cider on the pumps, two quiz nights per month and a decent set of regulars who are attracted by its quiet, old-fashioned, atmosphere.

I perused the blackboards by the bar and was caught by the offer of a 'Falcon Egg'. Always a sucker for an ovum-based snack, I asked the obvious question.

'It's a scotch egg,' came the reply.

'Oh.' I tried to hide my disappointment.

'They're made especially for the pub.'

I'll leave the falcon egg to the meat eaters among you. Of more interest – to me at least – is the 'Pudding Club' that the pub hosts. A main course is followed by seven (yes, seven!) puddings to taste, along with accompanying pudding wines. Now we're talking!

Turn right out of the door to The Falcon. You should now be on a large paved area. To your left, across the road, you will see a rather impressive nineteenth-century almshouse with a clock tower over a large arched gate. This is Canning Terrace. Turn your back to this and walk forwards. In a hundred yards or so, you will be at The Sir John Borlase Warren.

16. The Sir John Borlase Warren

Whereas The Over Draught has a heavy focus on craft beers, The Sir John Borlase Warren is all about real ales. Owned by the Hucknall-based Lincoln Green Brewery, this pub does not allow craft beers in the main bar. Instead, there is an enticing range of hand pumps. They do sell lager, but it is discreetly placed at the back, so as not to offend any CAMRA members who might stagger in.

Fire in the grate, The Sir John Borlase Warren.

If beer is not your thing, they also offer an extraordinary range of over 100 types of gin – a hangover (no pun intended) from a former landlord who was something of an aficionado.

The landlady showed me around, pointing out the coals burning in the grate and the pleasant outdoor area with seating, cushions, candles and flowers. There was a cosy snug for the older regulars to sit and drink gin – a comfy eating area and some classy chandeliers hanging from the ceiling. For her, everything has to be real: 'Real fire, real ale, real pub, real people!' It is perhaps this insistence on old-fashioned pub values that makes what has sprung up in the garden particularly surprising...

Exit the pub through the rear entrance to enter the beer garden. Here, unexpectedly, you will find our next pub, The Dog & Thief.

17. The Dog & Thief

What do you do if you run an old-fashioned pub in an area that is teeming with students all keen to drink the latest trendy craft beers. You don't want to upset the old guard by sullying your pub with this juvenile fluff – it might put them off their gin! The answer: open another pub in your beer garden. Genius!

The Dog & Thief can be accessed from the street, without even having to go through the The Sir John Borlase Warren. The beer cellar is housed behind Perspex and lit with mood lighting so that the hip, pretty young things who now inhabit Canning Circus can gaze into it as they sip beers whose pump clips are too luridly coloured and funky for a home in the host pub.

This is a cool hangout for students keen for a quite pint or two before hitting the bright lights of the city centre. I look at it fondly, and with a warm thrill of nostalgia for the days when I too knew how young people spoke and didn't use words like 'hip' and 'funky' to describe things that I wish I still enjoyed and understood.

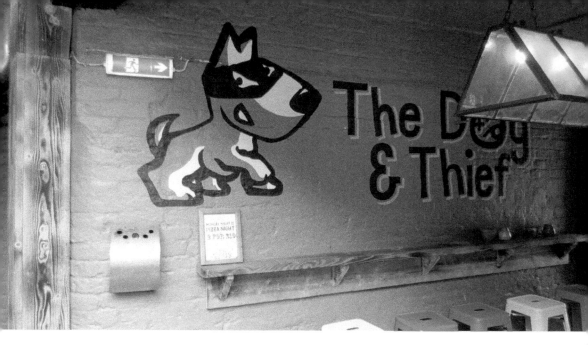

Above: A pub within a pub, The Dog & Thief.

Right: Up on the roof at The Sir John Borlase Warren and The Dog & Thief.

Re-enter The Sir John Borlase Warren, and then exit through the front entrance. Use the pelican crossing that is directly in front of you. Now turn left to head down Derby Road. After a couple of minutes, you will be at The Hand in Heart.

18. The Hand in Heart

The Hand in Heart plays a neat trick on the unwary punter. The outside looks rather unengaging: a blocky mid- to late twentieth-century eyesore beside a busy main road. Step through the door, however, and you are in an antiquarian wonderland. Hewn out of the rock, this gloomy cave, with wooden floors, a huge old dresser in the corner and a beautifully carved mahogany bar, is a true find. Surely it must vie with The Olde Trip for sheer antiquity? Why is this medieval survival not ranked alongside the other historic pubs of the city?

Not as old as it seems, The Hand in Heart.

Because it isn't what it seems. The Hand in Heart has played its second trick upon you. I used to know a bloke who had worked on digging out and extending the caves in the early 1990s. Don't let this act of fakery put you off, however. This is still a beautiful little pub – a perfect place for a quiet chat in a gloomy recess, and an ideal location for a first date.

The upstairs gallery area would be far less appealing to the modern-day troglodyte, although it is still blessed with its own charm – especially the smoking area, which allows one to indulge in one's habits while sitting on a carved tree trunk and watching the good people of Derby Road going about their business.

The pub has a good selection of beers, as well as a slightly pricey menu. It opens for breakfast at 8.30 a.m. and is licensed to sell alcohol from that time (should the mood take you). It even has its own house brew – Round Heart.

Tickle the ivories at The Hand in Heart.

Personally, I tend to drop in on a Thursday evening, for the weekly live music sessions. These are often reassuringly eccentric, with a good variety of unusual musical styles represented – from Balkan-flavoured rock to Django/Grappelli-style jazz and freak folk. There is even a piano in a secluded corner, although I am yet to see anyone actually playing it...

Turn right out of The Hand in Heart. When you come to a pelican crossing, cross onto the other side of the road and continue down the hill. You will soon arrive at A Room With a Brew.

19. A Room With a Brew

The landlord of A Room With a Brew is a bit of a wag. The jokes, wordplay and dubious anecdotes come thick and fast when you enter this little micropub with big literary aspirations.

'Don't believe a word that he says!' advised his wife, as he finished telling me about the 20p discount that he gives to students, CAMRA members and people over eighty-four who come in with their grandparents. 'I had to give it to one old feller who came in clutching an urn!'

A Room With a Brew is the Scribblers Brewery tap. 'We're based in St Appleford,' he told me, 'and we all know where that is!'

I looked confused.

'Say it fast!' (Stapleford is one of the suburbs of Nottingham.)

More puns, A Room With a Brew.

The pub is full of books. You can take one away with you to read, so long as you make a donation to replace it. Lots of people just come in to sit and read over a pint. The landlord cum brewer likes books. A lot.

All of Scribblers' ales are named after famous literary works – One Brew Over the Cuckoo's Nest, Beerfest at Tiffany's, Masher in the Rye. He obviously has a penchant for mid-twentieth-century American literature, although there are nods to modernity with Hoppy Potter and the Goblet of Ale, and my particular favourite, Life of IPA.

'We always have between two and four guest beers, nine gins, three whiskies, one or two vodkas and some soft drinks like lager.'

Given his taste in books, I wondered if he was a fan of *Catch 22*. Joseph Heller had a tendency to bombard his readers with an endless barrage of witticisms.

'Contrary to popular belief, we don't put cocaine in the beer to make it sell faster and we have cut down on the amount of creosote that we add.'

The pub is quite small, and on busy days it is full to capacity with forty five people. At all times, it is filled with the landlord's personality. I like this guy. He obviously thoroughly enjoys what he does. He shared a bit of taproom philosophy with me: 'I think it was Confucius who said, "Give a man a job that he loves and he'll never work again."' Now that's wisdom.

The pub part of this walk ends here, but I would like to take this opportunity to share a nice little surprise with my readers. When leaving A Room With a Brew, turn left. There is a pelican crossing a few yards away. Use this. In front of you, you will see a private, gated car park with a pedestrian entry next to it. This is a public right of way. Enter and go directly forwards into what looks like the entrance to a multistorey car park. Here you will find…

…I won't spoil the surprise!

'Make mine a literary reference!' A Room With a Brew.

4

Heading to Sneinton

Originally a separate settlement entirely, what was the village of Sneinton has now been absorbed into the city of Nottingham. It still retains a character of its own, however, with sandstone caves and the iconic Green's Windmill lending an air of pastoral charm that belies its closeness to the city centre. Sneinton may have been the birthplace of William Booth (founder of the Salvation Army), but a walk there offers those of us who have failed to take the temperance pledge plenty of opportunities for a decent drink. From a beer in a chip shop, to a market trader's boozer and a traditional English folk session, this is the walk into Sneinton.

 Start on Sneinton Marketplace. Look around you and you should clearly be able to see The Bath Inn.

The Bath Inn, viewed from Sneinton Marketplace.

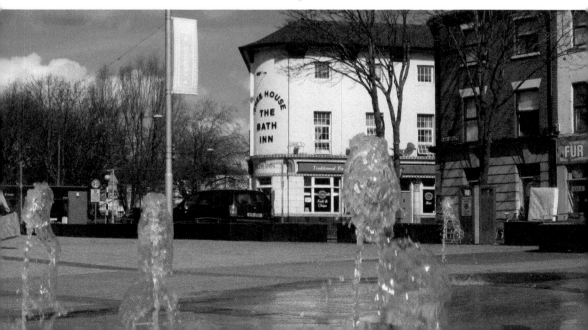

20. The Bath Inn

Look beyond the striking, listed exterior of the Bath Inn and you will find something that is unique in Nottingham. There may be other pubs like it elsewhere, but I have yet to find one. There are two rooms: one contains a simple, no-frills bar of the kind that was common a couple of decades ago, the other houses a traditional English fish and chip shop.

'You tell your missus that you're just popping out to get fish and chips,' explained the landlady, 'and you can stop for a pint without her even knowing.' Genius! You can, of course, have your chips in the bar and wash them down with a beer. What could be better than that? An Englishman's dream come true.

This is a friendly, working-class pub of the sort that is – sadly – under threat of extinction. There is only one hand pump on the bar; this is a pub that has no pretensions to being a darling of CAMRA. At one time, they had live music (I have played there on a couple of occasions), but they have eschewed that in favour of karaoke and a disco every Saturday night. If anyone has an acoustic guitar, they're welcome to lead a sing-song though – it's that kind of place.

This is definitely a local pub for local people – regulars prop up the bar, chewing the fat. They all seem to know each other and they celebrate and commiserate together. Whenever one of them has a birthday they throw a party. Any excuse.

'This pub is a personal little pub,' one of the locals told me, as he enthused about how welcoming and open it was. Anyone is accepted here. A couple of streets away is Stonebridge City Farm, a fantastic little community project that is largely manned by volunteers with learning disabilities. Many of these are regulars in The Bath Inn, where they receive the same enthusiastic welcome and the same birthday celebrations as everyone else. That's community spirit in double measures.

Exit the pub and use the zebra crossing to get back to the marketplace. Turn left and follow the direction of the road. After a couple of minutes you will come to a busy main road that runs at right angles to the one that you are on. Turn right here. You will soon find, on your right, the Fox & Grapes.

Chips and beer! The Bath Inn.

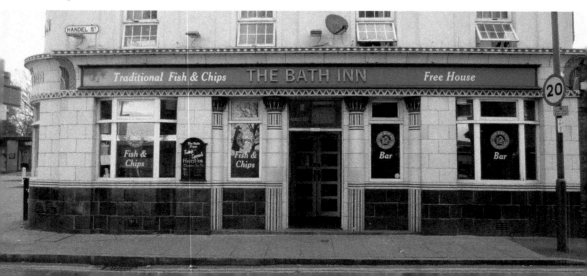

21. The Fox & Grapes

The Fox & Grapes was, like most of the rest of the buildings on Sneinton Market's 'lanes', dilapidated for many years. For a long time it had been a boarded-up shell, bearing a grubby pub sign that read 'Peggers'. In recent years the market has been rejuvenated, with new businesses moving into the buildings. Castle Rock has taken over the sorry old market trader's pub, revived its original name and spruced the place up a bit.

Memories of its heyday still hang over the place. The new manager has been keen to look through the archives for titbits of the pub's chequered past: a news article about a murder in the bar (someone had been picked up and then thrown to the ground, breaking their neck), the notorious 6.30 a.m. opening hours so that the traders could have a pre-work snifter, the gooseberry competitions that drew competitors from far and wide, and so on.

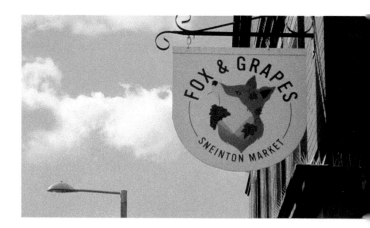

Right: A Foxy rebranding, the Fox & Grapes.

Below: Inside the Fox & Grapes.

Things are, perhaps, a little less colourful now, but then we live in far less interesting times. Clean looking and respectable, the Fox & Grapes has a varied clientele, a good selection of local beers, a food menu and acoustic music on Tuesday evenings.

They also do very nicely out of being just around the corner from the National Ice Arena – home of the Nottingham Panthers, as well as a prestigious venue for big stadium acts.

Leave the Fox & Grapes and turn left to retrace your steps. When you come to a pelican crossing, use it to get over the main road that you have been following. Directly in front of you should be a road with two billboards at the end of it. Take this and in a few seconds you will arrive at The New Castle.

22. The New Castle

I had walked passed The Lamp, as The New Castle used to be called, on numerous occasions. Never, in those days, had I been tempted to go in. The place had a terrible reputation that matched its rundown appearance.

The pleasant little old lady who now owns it took me through its story. She had once ran a nearby pub called The Castle. The Lamp, which had been closed for several years and was in a terrible state of disrepair, came up for sale. She had bought it, gutted it and turned it into one of the most welcoming pubs in Nottingham. The ceilings had come down, all of the windows had been replaced, walls had been removed, a conservatory built, hanging baskets and window boxes had been put out the front (the lady was obviously a keen horticulturist – she showed me, with some pride, the plants that she had been growing in the narrow strip of yard that runs around the conservatory). To distance the property from its former reputation, she re-christened it The New Castle, in honour of the pub that she had left behind.

The New Castle.

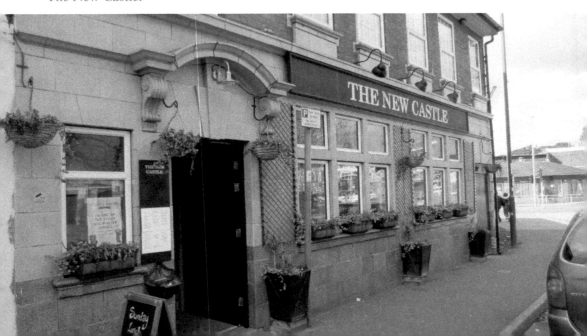

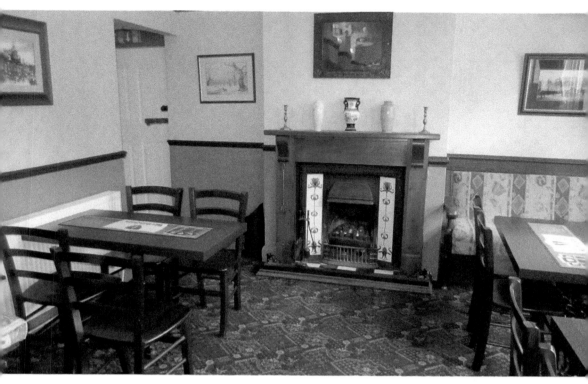

A warm welcome, The New Castle.

Unlike the Fox & Grapes, which has refurbished an old derelict building and created something very modern and new, The New Castle is filled with old-world charm. There is no TV set – she doesn't like the way that they dominate a pub. There is just some quiet music on the radio. As I chatted to her, Cliff and the Shadows were singing about what it was like to be 'Young Ones', extenuating the feeling that I had stepped back in time. 'This is a talking boozer,' she explained. 'We have a lot of roaring debates, and no subjects are off limits – even sex and politics.' Drunkenness and swearing are, however, beyond the pale of acceptable behaviour. It's a respectable, open place where families and dogs are welcome. They also have a pool table – a vanishing commodity in the world of the modern pub.

There is food on offer at an incredibly reasonable price (the average meal costs around £4, with Sunday dinners costing £5.25). The landlady was particularly proud that they did lamb on a Sunday. 'Not a lot of places do that,' she told me.

When I spoke to her, her pet project was getting the caves beneath the pub open for visitors. She told me that they date back to at least the eighteenth century (as evidenced by the presence of a stone, rather than brick, pillar). At that time, this was the site of a brewhouse, and there is a well in the caves that provided the water. In the intervening years the caves have been flooded, leaving 5 tons of silt to be removed. She hopes, eventually, to be able to offer tours.

I left The New Castle, vowing to take my family there for some food. I shall certainly no longer pass it by as I did when it was the, less salubrious, Lamp.

Exit The New Castle and turn right to follow the road as it goes round a right-hand bend. In less than a minute you will be at The King Billy.

23. The King Billy

The King Billy – formally the King William the Fourth – has a similar history to The New Castle. Formally a Shipstone's pub, it had an awful reputation. Like The Lamp, it was closed and fell into dereliction.

In the 2000s, it was taken on by Jeff Blythe – a popular Nottingham landlord – who reopened the place and turned it into one of the most well-regarded pubs in the city. It is now run by his son, Jon. There is a cosy, old-fashioned charm to the place – a charm that is certainly appreciated by the local folk and artistic communities.

I first became aware of the place through the famed Irish session that is held there every Thursday evening. More to my taste is the English session, hosted by members of The Foresters Morrismen, on the second Tuesday of each month. Both provide a pleasant background to a drink, a chat and a freshly made cob (outsiders call them bread rolls). The latter also offers a great opportunity to join in – perhaps by belting out a chorus of 'Nottingham Ale' – should you feel so inclined.

In early springtime the pub hosts an annual, month-long exhibition by local artists. There are pieces all around the pub and a related magazine for sale behind the bar. This contains examples of the art and a selection of poetry. The barman was keen to show me a piece that he had written for it.

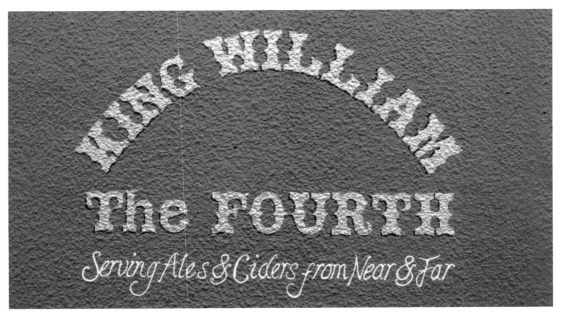

The King Billy's mission statement.

One of the regulars, The King Billy.

In terms of beer, The King Billy has a great selection of real ales from local microbreweries. It is the only place where you are able to buy the produce of the Sneinton Cider Company – the creation of some local brewing enthusiasts that, even at £4 per pint, easily sells out on the day that it is put on.

Upstairs, is a pool table and a place to play darts. There is a first-floor beer garden that acts as a bit of a sun trap in the summer months. One of the locals was keen to tell me about how great it was between the months of April and September. 'Make sure you don't bring too many people here though,' he warned me. He liked the fact that the pub was just far enough away from the city centre so as not to be perpetually swamped by customers. He didn't want his peace to be disturbed.

Leave the pub and use the zebra crossing that is slightly to the right of the door. Once across the road, turn left and follow the pavement as it leads round a right-hand bend. You should now be on Sneinton Road. Follow this road, passing some shops on your left and, slightly further on, a church on your right. After a couple of minutes, you should see a windmill on your left.

This is Green's Windmill. Built in the nineteenth century, it had fallen into disrepair until it was restored to working order in the 1980s. It was owned by the Green family, the most notable of whom – George Green – was an almost entirely self-taught mathematician. His discoveries in the fields of electricity and magnetism were groundbreaking and are still used in electronic engineering to this very day. It is free to

look around the windmill and there is a science centre attached. You can also buy flour that has been ground on-site. The area surrounding it is perfect for a picnic, especially on milling days, when the turning sails are quite majestic.

Carry on along this road. You will find a number of side streets to your right. When you come to Lord Nelson Street, turn right down here. On the left-hand side of the road you will find, the appropriately named, The Lord Nelson.

24. The Lord Nelson

On the history walk, we visited the three oldest pubs in the city. The Lord Nelson, for all its backstreet charm, may well be numbered among them. Originally two cottages and a coaching inn that have been knocked together, it is claimed that the pub is 500 years old and that the seemingly endless rows of Victorian terraces that surround it are merely newcomers that have sprung up in recent times. Certainly, if you stand in the beer garden and look up at the building, you could easily imagine that you were outside a quirky country pub, far from the city.

Unlike some of the other historic pubs in Nottingham, the Lord Nelson doesn't have a touristy vibe – it doesn't cash in on its age and is content to be a regular pub. There is talk of heritage funding to get the caves below up to a suitable standard for the obligatory cave tours, but that definitely feels like a sideline.

Even the real ale on the bar – the pride of many modern pubs – is a little bit of a side issue. What really matters to the landlady of the Lord Nelson, who has been drinking in the pub since she was eighteen, is community. I hear that from a lot of people that run pubs, but this is a woman who is prepared to put her money where her mouth is. She runs a fantastic little project called 'Everybody Eats', which is aimed at feeding the good people of Sneinton.

A country pub in the city, the Lord Nelson.

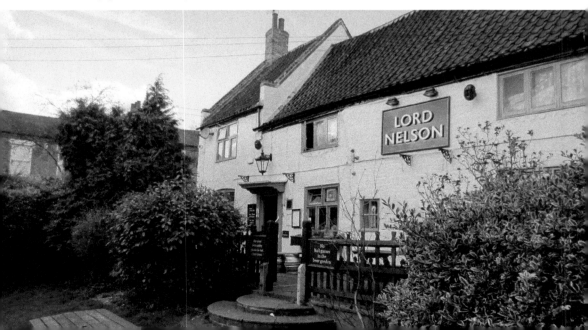

Having started out as a Christmas meal for the homeless, the project now provides a free meal to the whole community on the third Saturday of the month. The day before my visit, she had provided eighty meals. There is a jar on the bar for money donations, but she also accepts food. The local allotments provide her with fresh veg, and a bakery stall on Sneinton market gives her bread. 'It's the community feeding itself; we're all feeding each other.'

She also provides food parcels. Unlike many food banks, she doesn't require a ticket, just a discreet word in her shell-like.

This pub is definitely a focal point for the local community. It hosts the after party for the Sneinton Festival each year, with a marquee in the garden and a whole day of live music.

Aside from this, there are some nice, friendly touches that only really come in a pub that has a loyal gang of locals. Wednesday nights are officially dubbed *'Whitney Wednesdays'*. If a Whitney Houston song comes on the radio, the first person to the bar gets a free drink. This really does feel like a pub that's out in the sticks!

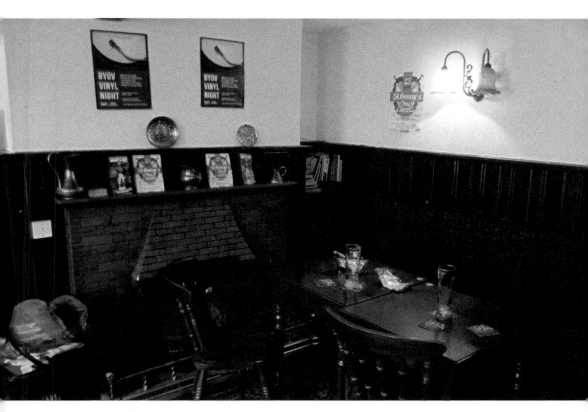

Inside the Lord Nelson.

5

The Industry Walk

Bicycles, cigarettes and pharmaceuticals have all played major roles in Nottingham's manufacturing economy, but for many years the city's most famous export was lace. The huge warehouses that dominate the Lace Market area of town stand as an impressive relic of this industrial past. Starting here, this walk will lead you past the imposing Galleries of Justice and the ultra-modern Nottingham Contemporary. You will also have a chance to play some traditional pub games, have a beer in a railway cabman's shelter and visit the home of an award-winning real ale.

This walk begins at St Mary's Church. This beautiful medieval church stands at the very heart of the Lace Market. It is well worth popping inside, if only to see the unbelievably camp statue of a unicorn that flanks the aisle alongside his ancient foe, the lion. A circuit of the cobbled streets that surround the church on all four sides will also give you a good impression of the past glories of the local lace industry. See if you can spot the offices of a law firm run by one Rupert Bear. It always makes me chuckle.

Standing at the foot of the steps that lead up to the main gate of the church, turn right to head up St Mary's Gate. On your left, you will find the Kean's Head.

25. Kean's Head

The Kean's Head is named after the famous nineteenth-century Shakespearean actor, Edmund Kean. He was known to have performed at the original Theatre Royal, which was also located on St Mary's Gate. The pub's logo is based upon his portrayal of Hamlet. On the pub sign and on various branded material within the building, he can be seen holding Yorik's skull and musing upon the nature of mortality.

Formally an adjunct to a lace factory, the Kean's Head has been a pub since the early 1990s. It is currently owned by the Castle Rock Brewery, who purchased it in 2004. It is an attractive pub with a cosy red-brick interior and a quiet, friendly feel. The staff are warm and welcoming and seem quite pleased to be a little off the beaten track. The bar manager likes to refer to it as a hidden gem.

All of the staff are very keen (no pun intended) on the quality and variety of drinks provided. There is a huge selection of spirits behind the bar, with whisky and gin being

Above: The Keane's Head.

Right: A selection of gin, the Keane's Head.

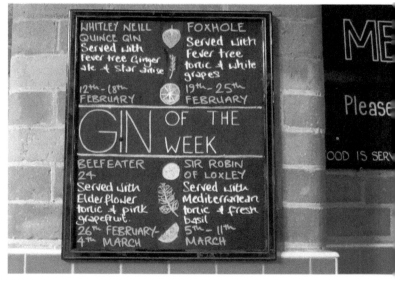

their speciality. Indeed, they always have special gin of the week, with forthcoming gins advertised on a blackboard on the wall. In terms of beer, while they are a Castle Rock pub, they do have occasional 'Tap Takeovers', where a guest brewery will be featured for a week. The expert staff go to great lengths to secure unusual beers that are unlikely to be available elsewhere. Recently they had a Tap Takeover by some small, independent, Scandanavian breweries.

They also regularly have a selection of quality ales and craft beers to suit any palate or purse, with a regular pint coming in at around the £3.20 mark, whereas a top-quality 12 per cent porter might set you back £15 (fortunately for both your head and your pocket, they are also available in one-third, half and two-thirds measures). They also have a nice menu of fresh food cooked on-site.

This is definitely a bolthole for people that want to get away from the busier parts of town. There are a loyal bunch of regulars, who are in attendance most evenings. The staff tend to give them nicknames based upon the drinks that they usually order – my particular favourite being the enviably named 'Screech Owl Steve.'

Being opposite the church, it is also a favoured haunt of the spiritually minded, with the choir dropping in three times a week. Not to be outdone, the choirmaster habitually comes in for a drink most days.

For me, the most intriguing thing about this pub are the double cellars. Unlike many of the cellars in Nottingham, they are red brick, rather than carved out of sandstone. Experts have said that they believe they were once connected to the Galleries of Justice. One cannot help but picture the evocative scenes of condemned men and desperate felons in those subterranean vaults. Not currently open to the public, they stand unused. They are, apparently, a wonderful space and it would be nice to think – fire regulations permitting – that they could be put to good use as a part of the pub in the future.

Exit the pub and turn right to retrace your steps. At the bottom of the road turn right onto High Pavement. On your left, you will see the National Justice Museum. The site was being used as a law court from as early as the fourteenth century. A gaol soon followed and, over the years, the 'facilities' were expanded, with a police station finally being added as recently as 1905. Official business was transferred to the newly built Crown Court in 1991, and since then the Galleries have housed a rather splendid museum, parts of which can be viewed for free. A quick glance down the alleyway by the old-fashioned, Dixon of Dock Green-style 'blue lamp', will reveal another great icon of 1960s TV – a vintage police box! On your right, you will find The Cock a Hoop.

26. The Cock a Hoop

The first thing that you will probably notice about The Cock a Hoop is the attractive front window. It is leaded and in a Tudor style, with the words 'Home Ales' picked out in a delicious Gothic script. It is perfectly in-keeping with the lovely building, which was once a professional's town house before becoming a county tavern in 1833.

Home Ales windows at The Cock a Hoop.

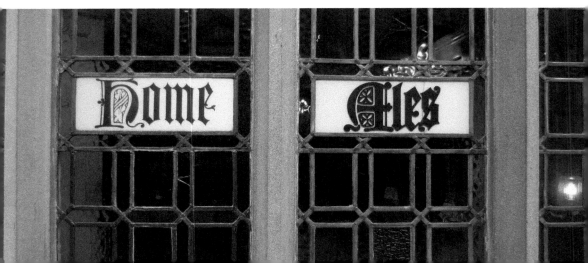

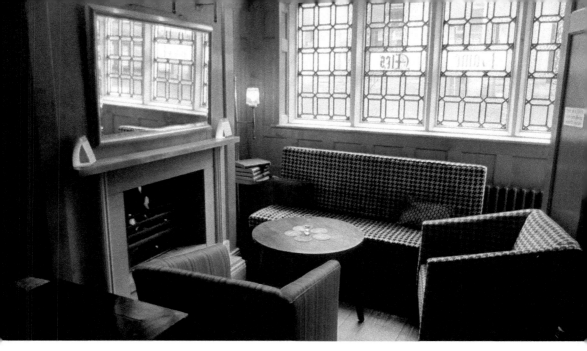

A quiet, cosy bolthole, The Cock a Hoop.

Its location, directly opposite the Galleries of Justice, has leant it a colourful past. There is a gated outdoor area used as a terrace in summer. This was once the parking space for the cart that collected the bodies of executed prisoners.

The landlord – a pleasant young man from the Continent (French perhaps) – was keen to sit me down by the fireplace. He regards this as the pub's greatest charm. Certainly, it acts as a feature in the small wood-panelled bar room. With old-fashioned mirrors on the walls and plush, high-backed chairs, this is a very cosy little retreat.

The Cock a Hoop is now a part of the Lace Market Hotel, but the landlord is keen that it should maintain its own separate identity. He enjoys the fact that it is very quiet and has a small, but loyal, band of regulars who come here to sit by the fire and relax.

There are two other rooms: a small dining room and a downstairs area, which has a separate cubbyhole and a small television that is for special occasions – the Olympics or the Rugby World Cup. They don't have Sky Sports as the landlord is keen not to attract the football crowd. 'If you want to sit alone there is a place for you,' smiles the charming host, who seems to value peace and quiet above all else.

He is keen to show off the selection of beers that he has on pump. All of them are local, with the farthest-flung brewery being as far away as Loughborough. On Mondays, all real ale is available for just £2.50 per pint. Being attached to a hotel, the pub also sells food, with a fine selection of high-quality meals. On Tuesdays, Wednesdays and Thursdays they offer meal and drink deals for £10.

I left The Cock a Hoop feeling mightily relaxed and ready to face an incredibly short walk to the next pub. Exit The Cock a Hoop, turn right and you will shortly arrive at The Lacemaker's Arms.

27. The Lacemaker's Arms

The Lacemaker's Arms opened in January 2018. One is struck, when walking through the door, that a lot of effort has been put in to making it look as though no effort has been put in. There are huge chunks of plaster missing from the walls, candles add their drips of wax to wine bottles on the tables (even in the middle of the day) and your reflection is barely discernible in the tarnished mirrors. It has a down-at-heel, Victorian, spit-and-sawdust vibe that has been carefully created by the owner. He runs several other drinking establishments in the area, but this the landlady was keen to assure me, is his passion project. Here, he is creating the kind of pub that he would like to drink in.

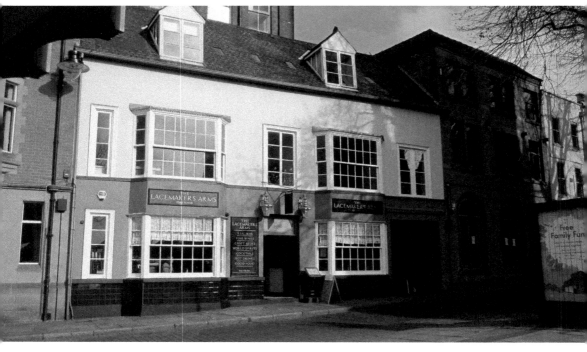

Above: The Lacemakers Arms.

Left: Shabby chic, The Lacemakers Arms.

The building has been through several uses over the years: from lace factory, to lace museum to public house. The lace theme has been upheld with lace being displayed on the walls and archive footage of the factories being projected in the back room.

This is a pub of two halves. The landlady describes it thus: 'Old world at the front, more urban and modern at the back. We want this to be uncomplicated. You get what you see. We want you to feel as though you walk in and you're instantly welcome.'

It's a very small team that runs the pub – only four of them – and they all took a hand in the decorating and getting the place up to scratch before opening.

They have high hopes for creating a real ale and craft beer scene in the Lace Market. They want to attract people to this area, enticing them away from the trendy cocktail bars and hipster cafés of nearby Hockley with a promise of something more substantial. 'We're only providing a few traditional cocktails using high-quality alcohol.' As she spoke, I found myself musing about what traditional cocktails were and how the poor landlord of The Cock-a-Hoop would react to being overrun by customers, drawn to this new social hotspot of an area by their sophisticated lure.

It's a very friendly pub and I wish them well in their mission to rejuvenate the Lace Market. Personally, I find it a little too gimmicky and modern (despite all appearances) for my tastes, but I am a dinosaur in a rapidly changing world.

Leave the pub and cross the road. You should be standing in front of the Nottingham Contemporary art gallery. The Nottingham Contemporary houses a wide, and often changing, range of exhibits that vary from the sublime to the ridiculous. There is a performance space with a café and licensed bar downstairs, should you wish to pop in for a look round and some refreshments. Also worth noting are the lacework patterns adorning the building's exterior.

Continue on to the end of the road. You should now see the Weekday Cross. Erected in the early part of the sixteenth century, this cross marks the site of Nottingham's original marketplace. Turn left here and walk down the hill, by the side of the Contemporary. Cross over the tram tracks and continue down the hill, following the pavement as it curves around to the left. Continue following it around the left-hand bend onto Canal Street. You will pass a row of shops, among which is the blue-tiled frontage of The Newshouse.

28. The Newshouse

The Newshouse couldn't be more different from The Lacemaker's Arms. A genuinely old-fashioned boozer, built in the early 1960s, its main draw is the selection of pub games that it offers. The blue-tiled and dun-brick exterior screams post-war functionality. What you see is what you get. It feels like the pubs of my youth. Some old men with thick Nottingham accents prop up the bar, while football matches are projected on the wall; nobody really watches them though – they're too busy chewing the fat.

In the nineteenth century, this area was one of the poorest slums in the whole of Nottingham. The original pub – The News House (two words) – had been exactly as it sounds: a place where illiterate slum dwellers could come to have the news read to them. Slum clearances in the 1920s and the Luftwaffe in the Blitz had swept away all that remains of that world, but the pub that now bears the name rose, phoenix-like, from the ashes.

'This is a pub. It's not pretending to be anything that it isn't.' The landlord gave a grim smile. 'That's a rarity nowadays.' Rarer still are the dartboard, the table skittles and the billiards table.

'It's the only one in Nottingham, but they've still managed to start a league.'

'Who do they play against?'

'Each other, in a singles league.'

The billiards table is a popular draw. It gets used every day.

The dartboard plays witness to perhaps the most extraordinary of the pub's customers – a blind darts player. Apparently, his technique is to stand on the oche, gripping the elbow of his throwing arm with the opposite hand. He then throws his first dart and asks the other players what he has scored. Using the hand that is gripping the elbow, he then adjusts his aim for the final two darts. By all accounts, he is very good.

This is obviously a pub with a good community of regulars, not all of whom are human. There are several dogs who have learned to come in and place their feet on the bar and demand service with a bark. The landlord is obviously far too generous with his treats. A tiny canine, too small to reach the bar, is in the habit of following him 'backstage' if she isn't given her dues.

The Newshouse was acquired by Castle Rock in the late 2000s and provides an excellent selection of local beers. All in all, this is a refreshingly honest and uncomplicated place to drink.

Exit the Newshouse and turn right to retrace your steps. When you reach the point where the road turns right, take the crossing to your left. Turn right once you are over the crossing to continue along Canal Street. You will pass Nottingham Crown Court on your left. Take the next left onto Carrington Street. You will walk by a row of shops on your left, where – next to a chip shop – you will find the Barley Twist.

Anyone for billiards? The Newshouse.

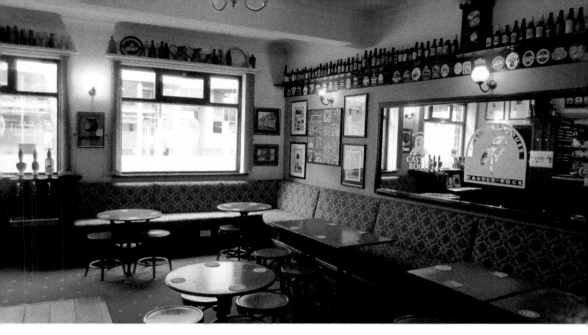

Inside The Newshouse.

29. The Barley Twist

In 2017, Castle Rock went on a bit of a spree. They opened the Yarn at the Royal Concert Hall, the Fox & Grapes at Sneinton Market (see pages 15 and 45 for details) and finally, in the week leading up to Christmas, it opened the Barley Twist.

This is a very new type of drinking establishment – not really a pub in the traditional sense (it describes itself as a 'craft beer and wine cellar') – and it shows that the people at Castle Rock have their fingers on the changing tide (to mix my metaphors) of British drinking culture.

The Barley Twist.

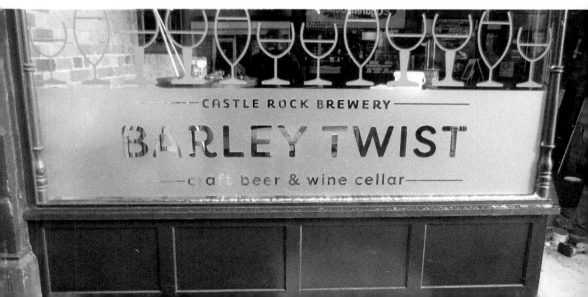

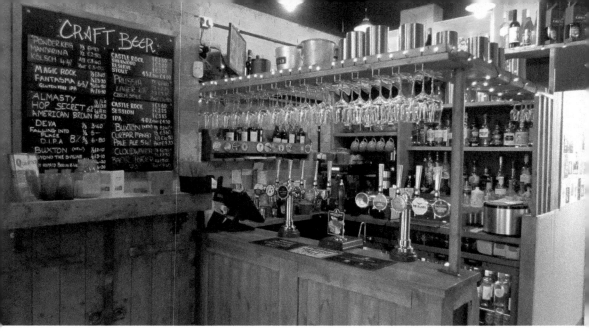

Inside the Barley Twist.

'The economy has started to improve,' explained the deputy manager, 'and the market has changed. People are becoming interested in craft beers and high-end wines. Coupled with this, a younger generation is uninterested in the traditional local. They are leaving the small towns and suburbs and heading into the cities for their nights out.'

The bar is certainly well situated – in between the Magistrates' Court and the Crown Court and on the main route from the railway station. This is a favourite haunt of lawyers and commuters. They have an early evening rush as thirsty office workers let off the head of steam that they have built up travelling to and from work by rail.

This is a place for young professionals and it is suitably classy. The alcohol on offer is top notch. All the beers are from the British Isles and the wines are of the highest quality. They do offer a discounted rate for carry-outs, should you wish to take a little of the finer things in life home with you.

Turn left as you exit the pub, continuing along Carrington Street. Continue for approximately three minutes, crossing a bridge over a canal. You will soon arrive at Nottingham railway station. Follow the pavement to the far end of the station and then turn left. Behind some railings, you should see an old cabman's shelter. This is now the home of BeerHeadZ.

30. BeerHeadZ

The cabman's shelter was originally used by the drivers of horse-drawn carriages that taxied passengers to and from the railway station. In those days, its main function was *not* to sell beer; it was a place for the cabmen to stay dry and sober away from the temptations of the public house.

Now, of course, the days of the horse-drawn carriage are long gone. After a stint as a rehearsal room for a railway worker's brass band, the shelter fell into disuse.

BeerHeadZ at Nottingham train station.

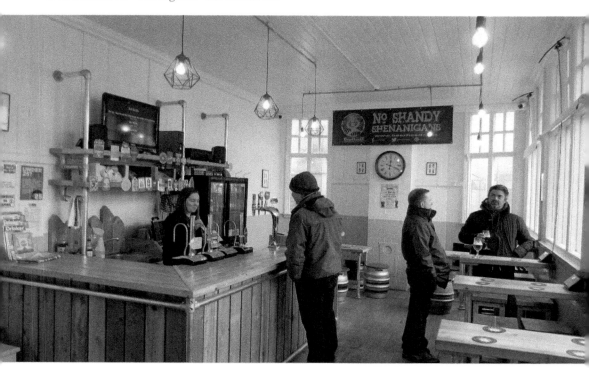

BeerHeadZ interior.

Without plumbing or electricity, it seemed an unlikely venue for a pub. A little heritage funding soon sorted that out, however, and the tiny, minimally furnished little hut is now perfectly situated to provide refreshments to thirsty commuters.

The little pub got off to a difficult start. Within six weeks of opening, a major fire at the station forced them to close. On the following day, Forest were playing at home. The police were persuaded to push back the cordon to allow the football fans in for a drink. They soon drank the place dry, on account of the storeroom still being behind the police line. It was a further several day before they were able to reopen.

This shaky beginning has not held the place back, however. Within a matter of months, BeerHeadZ was awarded CAMRA Cider Pub of the Year for Nottingham and went on to enter the regional finals.

Leave the pub and go out onto the main road that runs along the front of the train station. There is a crossing here. Use it and then turn left. Follow the pavement and in a few hundred yards you will arrive at the next pub.

31. The Vat and Fiddle

The Vat and Fiddle is the brewery tap for Castle Rock. It has been through several guises over the years, before formally opening as 'The Vat' in the 1990s.

The brewery is an imposing blue building directly behind the pub. It has grown into one of the major players (if not *the* major player) on the local brewing scene over

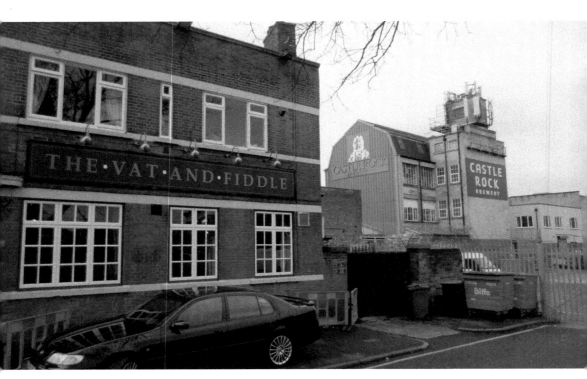

A new brewing giant, The Vat and Fiddle.

recent years. This is largely on the back of being awarded Supreme Champion Beer of Britain at the Great British Beer Festival, for Harvest Pale. It is a wonderful beer, and is almost always my tipple of choice.

This is an unpretentious, simple pub. They do food – nothing outlandish – with curry and a pint night on Tuesdays and pie and a pint on Wednesdays. They also offer tours of the brewery, at a cost of £12, for parties of ten or over. Not to worry if you don't have nine friends, however, as if there is already a tour going, you will be able to join it.

The pub is fairly sizeable and is usually quite busy. 'Never quiet, but always pleasant,' one of the regulars told me. Certainly, they have plenty of events on, with a big yard party held each May and plans to convert a part of the brewery into a hall that can hold a food market and larger functions.

The Vat and Fiddle is a firm, match-day favourite for football fans.

'Forest or County?' I asked one local.

'Forest!' came his adamant reply, almost before I had finished the dreaded 'C' word. This seems odd – the pub's located on the wrong side of the Trent for the City Ground!

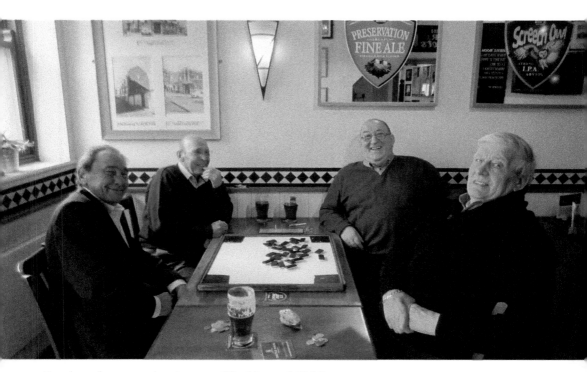

Sunday afternoon dominoes at The Vat and Fiddle.

6

Mansfield Road

Heading out of the centre of town, towards nearby Sherwood, this section of Mansfield Road has a character all of its own. Here, you can find restaurants serving cuisine from across the globe as well as numerous interesting shops, selling everything from second-hand books and records to fine art and ballet shoes. This road also has a fine collection of pubs, including the city's only entirely vegan pub, a pub designed by Nottingham's most beloved architect and one of the city's top alternative music venues.

Starting at the corner of Mansfield Road and Shakespeare Street, head up the hill, away from the centre of town. Across the road, to your right, you should see the intu Victoria shopping centre. After a few hundred yards you will arrive at The Peacock.

32. The Peacock
The unusual pub sign and beautiful frosted windows are only a hint of the joys that await you at this little pub. Stepping into The Peacock feels a little like stepping back in time, into a Regency sitting room. You are confronted by a wealth of ormolu, mounted animal heads and overbearing portraits. Around the walls, you will see gold-coloured buttons that work what is (probably) Nottingham's last 'bell service' system.

Gorgeous windows, The Peacock.

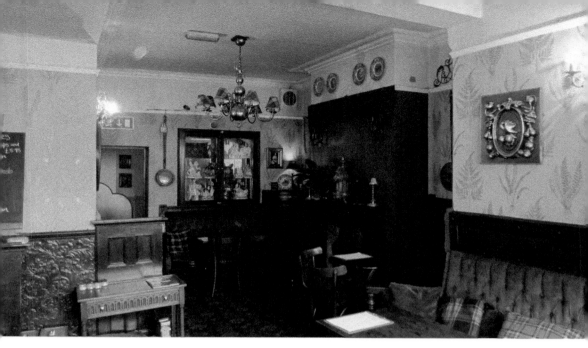

More Regency décor than you can shake a Jane Austen book at, The Peacock.

Formally a hotel, serving the long-vanished Victoria railway station (the remnants of which are now buried beneath the far less dignified shopping centre), The Peacock is now a treasured bolthole from the rigours of the city centre. According to a board on the outside wall, it was once a favourite haunt of D. H. Lawrence. This is easily imaginable, as it still retains a faintly arty, bohemian vibe.

In the daytime it is very quiet – the perfect place to sit with a pot of tea and a good book. At weekends, things liven up a little – the turntable that sits on the bar is used by a vinyl DJ. The playlist is suitably quirky, mainly consisting of obscure recordings from the 1950s to the 1970s.

Recently, the pub has become famous for its menu. It was the first completely vegan pub in Nottingham. This received a lot of attention from the local media. As a vegetarian, I have been craving fish and chips for years (contrary to popular belief, it is this and not bacon that I miss most!). The Peacock was able to provide me with a guilt-free alternative that was everything I dreamed of and more!

Upon leaving The Peacock, cross over Mansfield Road (there is a nearby pelican crossing, clearly visible). Here, you should be confronted with a rather striking red-brick building, which is the Rose of England.

33. The Rose of England
The Rose of England was designed by the sublime local architect Watson Fothergill in his usual, instantly recognisable style. It is one of his finest efforts, blending medieval and Tudor influences. The carving around the door is particularly fine, and tends to catch the eyes of passing foreign tourists. Many Americans are lured into the Rose of England hoping to find something typically British and, in a sense, they do.

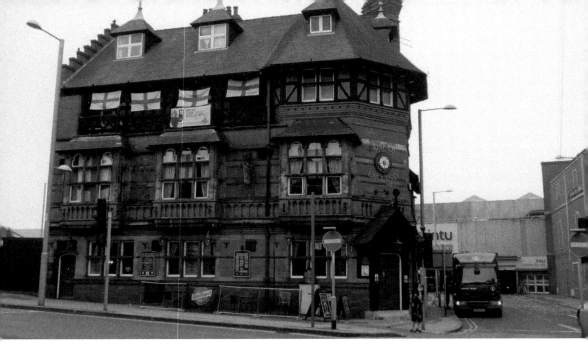

An architectural masterpiece, the Rose of England.

The pub has none of the airs and graces that might be suggested by its exterior. A large screen shows the football, St George's crosses hang from every surface, and posters advertise upcoming gigs (Rose Rocks, first Friday of the month), discos (last Saturday of the month) and quiz nights (every Monday). There is nothing pretentious or swanky about the place – it is a pub, pure and simple. I hope the Americans like it.

The landlord's daughter talked me through its history. She's taken a keen interest in these things and has spent a lot of time down at the Nottingham archives digging up nuggets of information. It is on the subject of ghosts that she becomes most effusive – her mother had been shocked by an inexplicable slamming door in the upstairs living quarters, and the dogs are often agitated by an unseen presence. This is a down-to-earth pub with a lot of history, gift-wrapped in the finest paper.

After leaving the Rose of England, continue to walk away from the centre of town. You will soon reach a crossing. Use this to cross Mansfield Road and then continue up the hill. After a few minutes' walk you will reach The Golden Fleece.

34. The Golden Fleece

Long before my time, the band that I currently play with used to rehearse in the deep cellars of The Fleece. Our accordion player still tells lurid tales (probably apocryphal) of a dark tunnel that lead away from the cave where they practised, into the unknown places, far beneath the city. The then landlady had to have it blocked up, as someone would come in at night and disturb her stock.

Perhaps this was one of the ghosts that is said to haunt the place. The current landlord is yet to see one, but is cautious when on the premises alone. Not that he has much

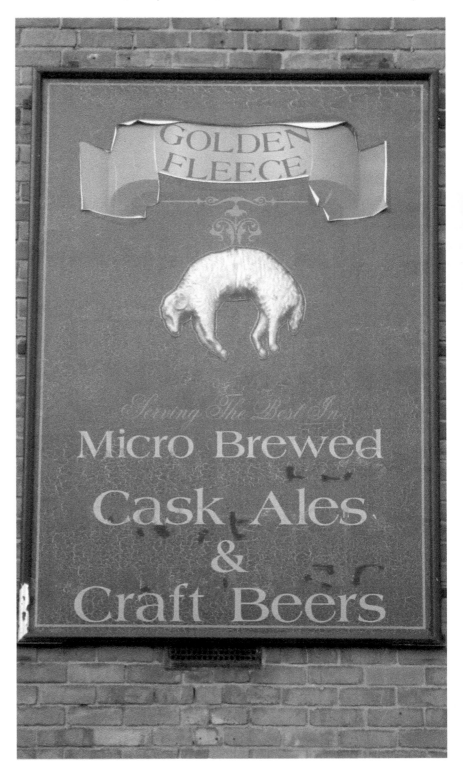

A macabre
pub sign,
the Golden
Fleece.

Nala – she-wolf of the Golden Fleece.

to fear with Nala, 'She-wolf of the Fleece', there to protect him. Nala is a gorgeous Siberian husky, and a great favourite of all of the locals.

Spooky stories aside, this is a music pub. There are occasional live sports (but only what's on the terrestrial channels), and you can find something to listen to on most nights of the week.

Tuesdays are acoustic nights, Thursdays are open mic and there are live bands on Friday, Saturday and Sunday. For fine days, there is a nice rooftop garden where you will be able to enjoy DJ sets while tucking into a BBQ.

A little further up the road from The Golden Fleece, you will find another pelican crossing. Use this to cross the road and then continue up the hill. You will soon arrive at The Nags Head.

35. The Nags Head

The Nags Head has a macabre past. In the early nineteenth century it was the final stopping point for condemned prisoners on their way to the gallows at the top of the hill. The landlord was keen to tell me the legend of one unfortunate who had wanted to have his ordeal over and done with as quickly as possible: he rushed his gaolers to the execution, meeting his fate too soon to receive the pardon that was winging its way to him.

The recent past has scarcely been more salubrious and I have tended to skip over the place when doing the Mansfield Road run – it has had a 'reputation'. The new landlord has worked hard to clean The Nags Head up. He's determined to keep a well-ordered pub. The rougher element has had to take refuge elsewhere. This is definitely a change for the better, as this is a place with many fine features, including a large outside space (proclaimed with a large sign, and no sense of irony, to be the 'Secret Garden'). There is

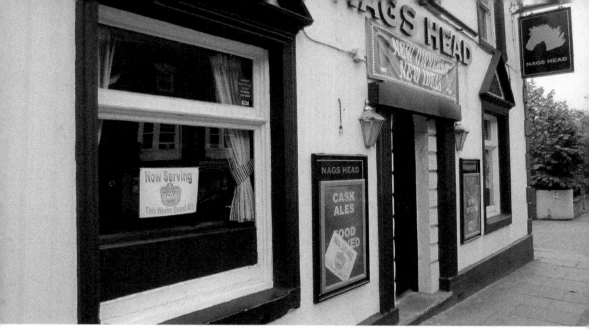

Above: The Nags
Head.

Right: The beer
garden, the Nags
Head.

also a pool table, some very plush seating and a function room. It is vastly improved
from the filthy dive that I remember from the past.

Like many of the pubs in the city, there are caves underneath and it is refreshing to
hear that the landlord has no intention of financially exploiting them. He occasionally
takes friends and family down for a little look, but only for interest's sake.

In many ways, this is a fine example of the typical English pub. They're just starting
to do real ale, but it's not a major focus. It's the really important things that count:
karaoke, live sports, BBQs and bingo afternoons on Tuesdays and Thursdays. In a
world of artisan pork scratchings and hand-crafted, locally sourced pump clips, it is
nice to know that there is still room for 'two little ducks', 'PC forty-nine' and 'those
lovely legs, eleven' – swit-swoo!

Head back down to the crossing that you used previously, cross the road and then head, once more, up the hill. A little further up than The Nags Head, you will find the Lincolnshire Poacher.

36. The Lincolnshire Poacher

At one time a confusing number of pubs on Mansfield Road were called some variation of the same name. Until 1989, The Poacher – one of the jewels in the crown of the Nottingham real ale scene – went by the name of The Old Grey Nag's Head. Evidence of this can still be seen dotted around the place to this day.

It is attractively furnished, with wooden floors and panelling, a cosy and private snug, and an airy conservatory. There is a sizeable backyard, which was once perfect for

Above: Beach huts at the Lincolnshire Poacher.

Left: A cosy snug, the Lincolnshire Poacher.

morris dancing, although the space has been drastically reduced by the introduction of a number of – admittedly very picturesque – beach huts. My one qualm is the mallard that seems to have been haphazardly nailed to the bar room wall mid-flight.

Like the Golden Fleece, The Poacher is blessed with a subterranean network of caves – three cellars on one level and then another 'deep cellar'. Sadly these are not open to the public, although this is perhaps a blessing as the bar manager is covered in scrapes and bruises from low-hanging water pipes.

Décor aside, the real draw of The Poacher is the beer. With thirteen very well-kept ales, as well as a large selection of bottled beers from around the world, this has become something of a Mecca for Nottingham's drinkers. If this is not enough to attract you, perhaps the live music (Wednesday and Sunday evenings) might grab you. If not, how about one of the many clubs that meet there: board gamers, chess, wine enthusiasts, pipe smokers…

Upon leaving the Lincolnshire Poacher, continue towards the top of the hill. You will soon arrive at The Forest Tavern.

37. The Forest Tavern/The Maze

One venue, although – confusingly – with two addresses. The pub at the front, opening onto Mansfield Road, is The Forest Tavern, and it is unremarkable enough. A fairly standard city boozer, save perhaps for the multitude of framed photographs that peer down at you from the wall. These are black and white images of musicians from pretty much any genre of popular music that you would care to mention. Whatever you're into, one of your heroes will be here. It didn't take me long to find Woody Guthrie and George Formby.

The back room, accessed through a small, poster-lined corridor, is The Maze. This technically has its own separate entrance onto North Sherwood Street, giving it its own address. The Maze has been one of the key music venues in Nottingham for as long as I can remember and, unlike places such as Rock City and The Running Horse, the musical fare is unashamedly eclectic: folk, country, heavy metal, reggae, drum and bass, experimental/avant garde … whatever it is, it is welcome here.

A corridor
of posters,
The Maze.

The Maze has played host to many Nottingham acts that have since gone on to make major impacts internationally. In recent years, Sleaford Mods have played there, and I can remember seeing Jake Bugg on the stage when he was no more than around fifteen or sixteen. A minor wave of excitement rippled through Nottingham some time ago, when punk legend John Ottway turned up to play the open mic.

The Maze also promotes international acts, often from the States via promotions company Cosmic America. I can remember seeing big names such a Pokey Lafarge in this, admittedly dingy, little room.

Music aside, this is still a pub and there is beer to be drunk. A member of the family that owns the Imperial Brewery in Yorkshire has a part share in The Maze, so there are close ties between the two. For any lager drinkers among you, you may also be interested to note that the cellar is fitted with a new Heineken 'Smart System'. This is the first independent pub in the city to be trialling the technology. I was taken into the cellar to admire the gleaming white boxes, flashing lights and curling green pipes that keep the beer in perfect condition, at a perfect temperature and with minimal wastage. If you order a pint of lager in here, you are tasting the future.

'Can you tell the difference?' I asked. I haven't drunk lager since I was a teenager, so I was keen to get an expert opinion.

'No, not really.'

God bless honest barmen everywhere.

A twenty-first-century technology that's keeping the beer just right, The Maze.

7

Sherwood and Carrington

The very word 'Sherwood' is apt to conjure up images of Robin Hood and his merry men, but this area of the city is a long way from what is left of the forest that shares its name. A bustling area with a bohemian feel, Sherwood is filled with quirky cafés and restaurants, as well as good quality charity and wholefood shops. It also hosts an annual arts festival and a weekly food market. The area is well serviced by buses from the city centre, with the most convenient being the lime and purple lines (run by NCT) and the Calverton Connection (run by Trent Barton). The area, and its close neighbour Carrington, also house some fine drinking establishments. This walk will take you to a modern-day gin emporium, a craft ale shop, an award-winning beer garden and a chemist that supplies a rather fine medicine.

Start at the Sherwood Winchester Street bus stop on Mansfield Road. Head up the hill, away from the city centre. You will come to a pelican crossing. Use this and continue up the hill. You will soon arrive at a red pillar box. Appropriately enough, this stands outside of The Pillar Box.

38. The Pillar Box

Karl, the owner of The Pillar Box (which takes its name from the iconic piece of street furniture that stands right outside), is a larger than life character, whose charisma permeates the whole establishment. A large portrait of him, complete with neatly curled moustache and fez, dominates one wall. Like all of the staff here, he is a thoroughly agreeable – and thoroughly eccentric – chap.

There is a certain Continental – Karl stops short of saying bohemian – feel to the place. The outlandish charm is enhanced by the various clocks (all set at slightly different times) that chime and cuckoo with gusto for several minutes around the hour.

This is a gin bar rather than a pub proper, boasting as it does the largest selection of gins in the city. At the time of writing they stock around 200 varieties, although they hope to get this up to 300 in time. They also have a relationship with an English vineyard, meaning that they stock that once unheard of beverage – English wine.

Above: An eccentric owner, keeping an eye on his customers, The Pillar Box.

Left: 'More gin sir?' The Pillar Box.

I don't really have a palate for gin or wine, but I am a huge lover of pastries and a good cheese board – both of which are available.

Until relatively recently the building had been a post office, the back garden of which had fallen into a deplorable state by the time Karl took it on. In among the weeds he found a plaque that had been put up to the memory of one of the women who had once worked there. Moved by the fact that her memorial garden had become so neglected, he launched a huge campaign in the local press to have it revived in her honour – even going so far as to appear on Notts TV. This sentiment caught the imagination of local people, making it all the more embarrassing for Karl when he found out that the woman in question was not – as he had assumed – dead, but was living quite happily in the nearby suburb of Arnold, where she could be regularly seen shopping on the high street.

This quixotic episode amply illustrates Karl's passion for creating an establishment with a solid community focus. It certainly has that, especially when it comes to the arts. Book groups and poetry groups meet there, and cinema evenings provide an opportunity to see a mixture of art-house movies and classic 'golden-age' films from the 1930s and '40s on the (admittedly not that big) big screen. There is also a space at the back that displays work by artists that do not usually get an opportunity to exhibit in mainstream galleries. The bar even acts as a live music venue, which is impressive considering its size, hosting regular performances by a variety local artistes, including your humble author!

Karl has aspirations that are bigger than the physical confines of The Pillar Box. The bar's staff are responsible for starting a local gin festival, complete with guest distilleries, craft stalls and live music. This is a welcome addition to what is already an impressive social calendar for Sherwood.

Exit The Pillar Box and turn left and continue down the hill towards the city centre. You will soon arrive at The Robin Hood.

39. The Robin Hood

Possibly the best thing about Sherwood is the sheer variety of drinking establishments that are available to the wandering lush. There really is something for everyone.

The Robin Hood could not be more different from The Pillar Box. This is an old-fashioned pub without any frills or pretensions.

The Robin Hood.

Inside the Robin Hood.

There is some rather nice wood panelling, should you be interested in that sort of thing, and an outdoor area that is pleasant enough. The main draw for me, however, is the presence of traditional pub games – a dart board, a pool table and a table football. Aside from that, well, it's just a typical pub – of the kind that is becoming far from typical. There are two real ales, just to show willing.

The landlady, a small woman of plain words, smiled at me indulgently. 'We're old fashioned. We have dominoes at the weekends; a General Knowledge Quiz on a Monday; a Music Quiz on a Thursday, Karaoke on a Friday and live music on a Saturday night and Sunday afternoon. We don't do food, just cobs.' (For any foreigners among you, a cob is a bread roll!)

Exit the pub and turn left. In a few yards, you will be at Finn Bars.

40. Finn Bars

The Irish bar is something of a global phenomenon. It is easy to imagine that there must be more Irish pubs outside of the Emerald Isle than within it. From Munich to Monterey, they have spread a clichéd, cartoon vision of Eire – resplendent with shamrocks, leprechauns and porter – throughout the civilised world.

Finn Bars is pretty typical. The orange, white and green bunting, Celtic typeface and selection of Irish whiskies leave you with no illusions as to the pub's theme. Pride of place is given to a large, black bottle of spirits, branded The Pogues Whisky. One wonders if this is the liquor that did for Shane MacGowan's teeth (not to mention his motor functions). It is probably best avoided.

Aside from the décor and the gaggle of old Irish men who convene in one corner to reminisce about the old country, this is a pub of the old, no thrills sort. Like The

Right: A peeling shamrock at Finn Bars.

Below: Inside Finn Bars.

Robin Hood, they have a disco and karaoke at the weekends. They also have dominoes on a Tuesday and 'sticky 13s' on a Wednesday. Some gambling machines flash and flicker against the back wall.

The pub also plays host to some stereotypically Irish music – old men warbling slushy ballads to backing tracks, or folk musicians repeating endless slip-jigs, reels and renditions of 'The Wild Rover' and 'The Fields of Athenry'.

I got chatting to one of the regulars. 'There're a lot of good friends here,' he told me in a thick Nottingham accent, 'We have a good laugh. Everyone's nice and friendly and there's no trouble!'

The friendly, community focus of the pub is made evident by the weekly events that it holds. Tuesday mornings are for mothers and toddlers. Toys are provided, coffee and

cake are for sale and there is even baby yoga in an upstairs room. At the other end of life's road is the 'Kindred Spirits' OAP group that meets there once a month. Irish or not, Finn Bars has something for everyone.

Turn right out of the pub, retracing your steps until you come to a pelican crossing (just outside of The Robin Hood). Use this to cross over to Kraft Werks.

41. Kraft Werks

It may only be situated on the other side of the road, but Kraft Werks couldn't be further away from The Robin Hood and Finn Bars. 'What is this place?' asked a woman as I stood outside, taking a photograph for the book. 'Is it a cafe? I see a lot of funny looking men going in and coming out.' Being a funny looking man myself, I went in.

Below left: Is it a pub or is it a shop? Kraft Werks.

Below right: When is a bar not a bar? Kraft Werks.

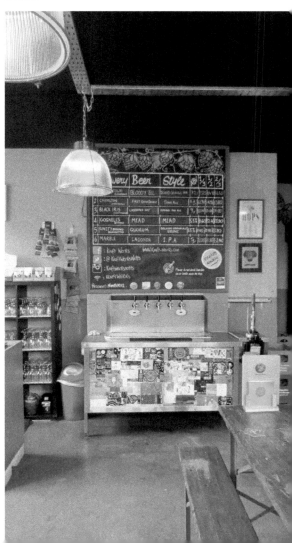

The first thing that you will notice as you enter Kraft Werks is the bar. It isn't where you would expect it to be. In fact, it isn't even where you wouldn't expect it to be. Look wherever you please and you won't find it. This is a bar without a bar.

Actually, the correct term for this place is 'Bottle Shop and Tap Room' – apparently a popular concept in places like America and Australia, where the population is rather spread out and carry-outs are common.

Kraft Werks is a fair-sized room, with long wooden benches in the middle and illuminated fridges all around the walls. These are filled with bottles of beer. Hundreds and hundreds of bottles of beer.

There's a row of taps, in an almost clinically sterile metal housing, with a blackboard over them, advertising the few none-bottled beers that they have. They are strong, expensive and prices are not given for pints.

No pints? No bar? Hundreds of different beers to choose from? I wondered how people took to this very alien concept. 'People are often a little confused at first, but they usually leave feeling happy,' the manager told me. Indeed, it's proving very popular, with people coming from all over the Midlands and South Yorkshire to get hold of rare and speciality beers. They even run an online click and collect service, a reminder that this is as much a shop as a 'pub'.

The focus is especially on craft beers. They don't do real ale ('You can get that anywhere, and we can't compete with the supermarkets on price') and they don't do wines and spirits. If a wine drinker comes in, the staff do their best to find them a beer that tastes like wine. One wonders what is the point. The aim here is to stock hard to find bottled beer that you can't get elsewhere. They have a good selection of Continental beers, especially from Belgium.

I asked him how the folks from CAMRA reacted to the place. 'Well, we do have one CAMRA member who comes in. He refuses to drink any of the beer, but he does go through the bins to get the labels off the bottles. The main challenge is getting them to accept that it doesn't matter how the beer is dispensed. It's just as good in bottles. Sometimes, it's better. Belgian style beers are bottle conditioned, which means that they're live beers with yeast in the bottle. A lot of CAMRA people don't see this.'

There are things about Kraft Werks that would easily lend themselves to mockery – certain trendy, hipster, clichés that fall close to the boundary of self-parody. They have, for example the best gluten-free selection in the city – a selection that leads one punter to bring his gluten-intolerant dog there. They also have a deal with a speciality pizza place up the road, who will deliver walnut and celeriac pizza to your table if you text them. It sounds pretentious (and probably is), but I can't bring myself to sneer at it. The staff are too friendly, too keen to help you to find your perfect beer and too wholehearted in their belief in what they are doing for you not to find yourself agreeing with them.

'You get people coming in who are used to drinking pints of pale beer that doesn't taste of anything. We're trying to get them to spend a little more for something of better quality that you don't need to drink as much of.'

I left the pub, somewhat under the manager's influence. This may not be my scene, but I can definitely appreciate what they're doing. *Viva la difference*!

Exit Kraft Werks and turn right. Carry on in this direction to the top of the hill. You should then turn right onto Bingham Road. On the corner, you will see some Victorian almshouses. These were built in the 1870s and were paid for by Miss Elizabeth and Miss Marianne Cullen in memory of their brother, James. They are still used as care homes to this day.

Carry on along Bingham Road. Bear left onto Loscoe Mount Road (you will see some interesting old houses to your left) and then turn left onto Watcombe Circus. Follow this round and then take the second left onto Loscoe Road. Follow this for a few hundred yards. You should pass a church on your left and a potter's studio on your right. Also on your right, you will find The Gladstone.

42. The Gladstone

The Gladstone, tucked away as it is on a little backstreet, is one of Nottingham's hidden wonders. It has high ceilings, delightfully old-fashioned furnishings (including a prominent portrait of William Gladstone in the lounge) and an award-winning beer garden. The latter is lovingly planted and cared for by the landlord in preparation for each summer. Hanging baskets and a myriad flowers attract the gentle droning of bees – the perfect accompaniment to a lazy afternoon with a pint of good ale and an improving book. And it is good ale. With no food or live music to distract punter and staff alike, the focus is on the beer. 'It has to be spot on.' And it is.

I say no live music, and in the main bit of the pub that is true, but upstairs on a Wednesday evening is a different story…

The Carrington Triangle is, perhaps, the oldest and – for my money – the best folk club in the city. Singers and musicians meet there each week to share songs, tunes

Inside The Gladstone.

The Carrington Triangle Folk Club, The Gladstone.

and poems of various styles from traditional to contemporary, comic to tragic, and sublime to ridiculous. Whether you fancy yourself as a performer or just fancy sitting and listening, if you happen to be passing on a Wednesday, this is a delightful way to spend an evening.

Back downstairs, I asked the barman to give me a sound bite to sum up the pub. He looked around at the friendly gang of locals who were propping up the bar. They laughed and joked together for a while, finally coming up with: 'A simple, old style pub – clean, presentable, with a nice atmosphere and good beer.' Succinct and unpretentious. I think that sums it up perfectly.

Exit The Gladstone and turn right to continue down the hill. After a couple of minutes, you will pass a row of garages on your left. Next to this, there is a sign marked 'Oak Street' and a pedestrianised walkway leading to a covered entryway. Use this to get back onto Mansfield Road. Turn right here and you will soon arrive at The Doctor's Orders.

43. The Doctor's Orders

The Doctor's Orders is a friendly little micropub, situated in what was once a chemist's shop. It was set up by three friends in the early 2010s, before being acquired by the Magpie Brewery.

It is a friendly, welcoming little place with table service, bar snacks provided by a local butcher and a varied clientele of eccentrics. These include a punk icon, a macaw who often brings his human in for a drink, and a particularly handsome dog called Jack.

'All dogs are welcome and loved, and I wouldn't want anyone to think that I had favourites.' Jack is obviously the manager's favourite.

There's a good selection of real ales from around the country, as well as an increasing range of craft beers. There is no piped music and plenty of games to play. This allows for plenty of chatter and one is never short of a minor celebrity or a tropical bird to talk to.

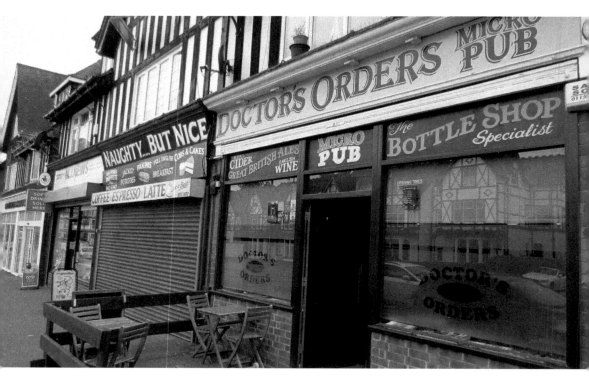

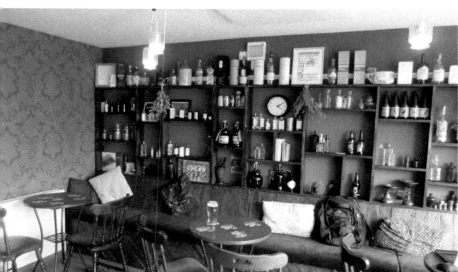

Above: Just what the Doctor Ordered.

Left: Inside the Doctor's Orders.

8

Kimberley

Attracted by the springs that may be still found in the countryside round about, two rival breweries, belonging to the Hardy and Hanson families respectively, were founded in Kimberley in the middle of the nineteenth century. They amalgamated in 1930 and for many years operated as one of the largest and oldest independent breweries in the country. They were eventually bought out by Green King in 2006. The iconic brewery building now stands empty – a forlorn reminder of the town's industrial past.

Still alive and flourishing, however, are the many pubs that the brewery left in its wake. It is well worth the short bus ride out of the city (Trent Barton's 'Rainbow One') to investigate an area that is so important to Nottingham's brewing heritage.

Start at the Kimberley Library bus stop that is on the left-hand side of the road as you come away from the city. Walk against the direction of traffic, back towards the city. You should see a mini roundabout at a crossroads. Turn right onto Greens Lane, keeping a large supermarket on your left and a shopping precinct on your right. Go to the top of the hill and follow the road as it curves round to the left. Continue on this road for around ten minutes, crossing a bridge over a dual carriageway. Eventually, on your right, you will come to The White Lion.

44. The White Lion

With open countryside and the impressive art deco water tower only a couple of minutes' walk away, The White Lion is a romantically situated and pleasant-looking pub. Until recently it had been somewhat neglected, becoming a dingy dive that only sold cans over the bar and was shunned by locals. Now, after an extensive refurbishment and a lot of hard work on the part of owners Graham and Yvonne, it is an attractive, airy and welcoming place to be.

With eight real ales on the main bar, and four or five on the back bar, this is definitely a beer pub in the traditional mould. It is unpretentious and reassuringly old fashioned and homely, with a regular quiz night and a skittles team. It has not fallen into the trap of becoming a gastro-pub, although food is served on a Sunday and 'Deb's Delicious Cobs' can be bought over the bar on Saturdays.

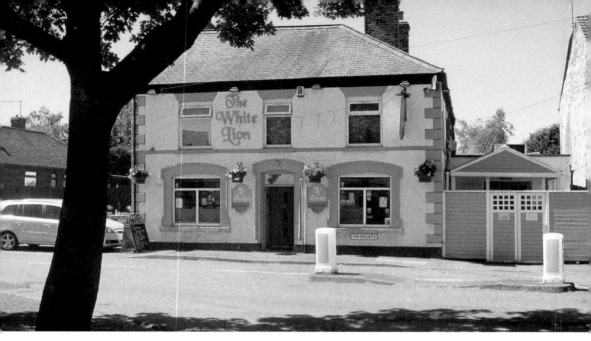

Above: The White Lion.

Left: A pleasant smoking shelter, The White Lion.

There is also a great family atmosphere to the place. The clientele tend to be over thirty, with lots of families and couples making this a regular haunt. A large, permanent marquee has been erected at the back for regular functions, gigs, Christenings etc.

For me, though, this is a pub that sits close to my heart for the paintings that decorate the back wall. They are of the Black Pig Border Morris, who dance there regularly. Among the band, you can plainly see a youngish man with a top hat, yellow sunglasses and a low-slung mandolin. The artist – a local man named Clive – has captured the odd way that the man stands, with the toes of one foot raised while he is playing, perfectly. That youngish mandolin player is none other than your humble author.

Exit the pub. You should see a road (Knowle Lane) running almost at right angles to the pub. Follow this and you will soon come to a park. Continue to follow the road until it peters out into a footpath. This will lead you to a bridge. Cross this and then descend the steep hill on the other side. Straight in front of you, on the other side of the main road, you should see The Stagg Inn.

45. The Stag Inn

The Stag Inn has always been a personal favourite of mine. Originally three separate cottages built in 1737, it probably first became a pub at the turn of the nineteenth century, although official records have only been traced back to the 1820s. Separated into two, cosily panelled, low-ceilinged rooms, the pub has a very homely and intimate feel.

For many years, The Stag was run by a lady called Karen. She fitted the pub with a number of vintage pub games, including One Armed Bandit and Devil Among the Shepherds, the latter of which was always one of the pub's main draws. Sadly, she took these with her when she retired. The new incumbents have made up for this loss, however, and business is booming.

A large area of decking has been installed at the front and the previously tired-looking garden has been rejuvenated. It is now a riot of colour, with flowers and hanging baskets surrounding the comfortable seating. Even the plastic tree house and slide that I used to play on as a child seems to have been given a new lease of life.

The bar at The Stag Inn.

The slide I used to play on as a boy! The Stag Inn.

The pub has a busy sports calendar, with links to the adjacent Kimberley Town Football Club and the nearby cricket club, as well regular summer and winter darts and dominoes leagues. Televised sport can now also be viewed in the bar (this is one change that I'm not sure that I approve of).

If, like me, you prefer the less competitive pursuits of beer and music, then you may be interested in the annual summer beer festival, which plays host to between twenty and twenty-four beers over a weekend, or in the Kimberley Jam. The 'Jam' takes place every June, with venues across the town playing host to a wide variety of live music. With its new look garden, The Stag was 'like Glastonbury' (although presumably much less muddy) on the first Jam day since the arrival of the new landlord.

Even when the beer festival is not on, there are seven cask ales and three posh lagers to be going at (with an increased selection proposed for the future).

Exit the pub car park and turn right to follow the main road. You will soon arrive at Roots.

46. Roots

For as long as I can remember, Roots was a shop that specialised in 'ethnic crafts'. It was large and gloomy and every available bit of space was taken up with hand-crafted carvings, elephant dung paper, tribal masks, Hindu effigies and didgeridoos.

It was on a trip to Thailand to source stock that the owners spotted a large, hand-crafted wooden bar. The base was a twisting knot of teak, which supported a beautiful flat surface carved from solid macaw.

'Like the parrot?' I interrupted this creation myth to ask the obvious question.

'I'm not sure – it was in Thai. I've never heard of it.'

Above: A bar made of solid parrots? Roots.

Right: Happy customers, Roots.

They fell in love with the bar and, after days of discussion, decided to buy it. They had no planning permission, no licences and no experience in the pub trade – but they had a dream. Roots would be a shop no longer – it would be a micropub. And their dream came true!

Decorated with various ethnic oddities that had been among their stock, Roots has a unique vibe to it.

They still sell some of the ethnic crafts that they had sourced, but the main focus now is on real ale. The 'macaw' proved to be unbelievably hard for a wood made from talking birds, but with a supreme effort, they managed to fit six hand pumps to it. They also sell some craft beers, lagers and gin – just to move with the times.

In front of the shop was a small car park. This has now been converted into a beer garden and it is perfectly situated to take advantage of the afternoon sun. Huge patio windows open out into this and, on a warm day, these can be pulled back to give the whole pub a bright, spacious, outdoor feel. When it is hot, you could almost imagine that you are only a stones-throw from a Phuket beach resort.

Leave the pub and continue down the hill. As you arrive back in the town centre, on your right, you will find The Lord Clyde.

47. The Lord Clyde

What is this strange connection with Thailand that Kimberley has developed? The side wall of The Clyde is plastered in fading and peeling posters, advertising the 'Bangkok Ladyboys'. This is only the first of the dismal signs that you will notice to mark the failing fortunes of the pub. Inside and out, it has started to look worn, which is a genuine shame.

The unusual railing that guards the 'hump' up to the pub's front door, the wide dormer windows and the gorgeous 'green man' panelling inside all tell of a pub that has a lot to offer, architecturally speaking. It is perfectly situated in the town centre, right across the road from the unusual domed war memorial, and at one time this was probably the most bustling pub in town. While never 'nice' in the conventional sense of the word, it was always lively and full – a tribute to past landlords and ladies who kept it busy with quiz nights, discos, skittle tournaments and televised sports.

Gorgeous woodwork, The Lord Clyde.

The dartboard has seen better days, The Lord Clyde.

Times have changed, however, and successive acts of vandalism have robbed it of much of its charm. Before my time, the two rooms that formed the pub were knocked into one. Since then, the panelled partitions that created little private spaces have been ripped out, as has the stage. The skittle alley now sits unused, as does the DJ booth. There are four hand pulls on the bar, but only one of them carries a pump clip: Hardy and Hanson's Best Bitter – a nod to the town's past.

The landlord seems resigned to his fate. His punters have abandoned him to drink in the next town over. 'People drink in Eastwood now. There are more pubs and it's cheaper.'

This was, and I'm sure will be again, a great pub. It just requires someone with the same vim and vigour as the owners of The White Lion and The Stag to take it on and bring it up to scratch. Dear reader, it may even be you.

In the meantime, you may content yourself with listening to the music channel that is played endlessly on a large, flat screen TV against the wall, while throwing a few arrows and speculating about how nice the place will be one day…

Exit the pub and turn right. Continue down Main Street for approximately a minute. On your right, you will come to The Gate Inn.

48. The Gate Inn
As a child, I was always aware that The Gate was a bikers' pub. The large car park at the front was always filled with motorcycles and the sorts of people, clad in black leather, that my parents eyed with suspicion.

Later, the pub came under the rule of the near-legendary landlord 'Brooksie'. Under his reign, it became a very 'blokey', football-focused establishment. It had an old-fashioned and masculine air to it – the atmosphere was drenched in fag smoke, stale beer and testosterone.

That was until 2013 when Dawn took over. With a woman at the helm, things had to change. Major alterations were made to the interior to bring it up to date. The long neglected beer garden was spruced up and opened to the public once more. (I had been drinking in there regularly for years and never even knew that there was a beer garden!). The wine selection was upgraded and a gin bar was added. This was a place for families – all were welcome, women and children included.

At first the menfolk revolted, but they have slowly grown to accept the changes. Now, parties mark every special occasion, and at many of them – Easter, Halloween, Christmas – children are the focus. There are always ice creams and lollies for them in the fridge and Father Christmas has added the pub to his busy list of seasonal engagements.

Of course, old habits die hard, and this is still a football pub – when there's a big game on, that still takes priority.

Whenever a special occasion does come around, Dawn is keen to mark it with a free buffet. There is also a free jukebox, between 5 and 7, every day. 'Freebies are the key. People like to think they're getting something for free!'

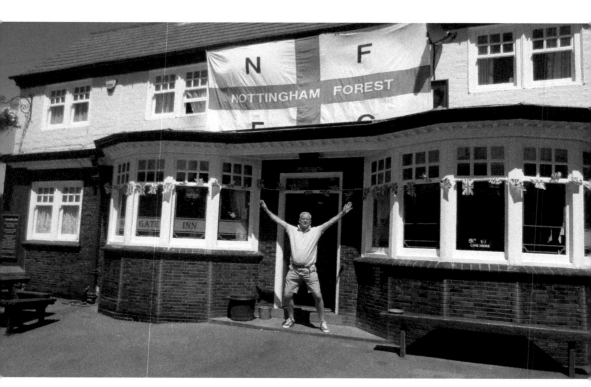

You Reds! Still a football pub, despite the feminine touch, The Gate Inn.

Caught sleeping, The Gate Inn.

Like the landlord of The Clyde, she has felt the pinch as punters have left her pub for the bright lights of Eastwood. She's learnt to be philosophical, however. 'They'll come back. In the meantime, I'm going to concentrate on the people that have remained loyal and look after those that have stayed.'

Exit the pub and turn right to come out of the car park. Cross the road onto the pedestrianised area. This is the Toll Bar Square. As well as Victorian-style street lamps, you should also be able to see some concrete beer barrels (representing the town's brewing past). There are mosaics on the floor depicting things of local and historical interest. Continue past the square. On your right, you will now see The Cricketers Rest.

49. The Cricketers Rest

The landlord of The Cricketers Rest – an ex-military man – runs a tight ship. The pub has passed into the hands of Castle Rock and they allow him a lot of leeway when it comes to which beers he stocks.

He is keen to take recommendations from his customers, and to supply beer that both he and his punters want to drink. His philosophy is both pure and simple: 'We're here to serve good beer to nice people.' He certainly does that. The pub has a very friendly, community feel.

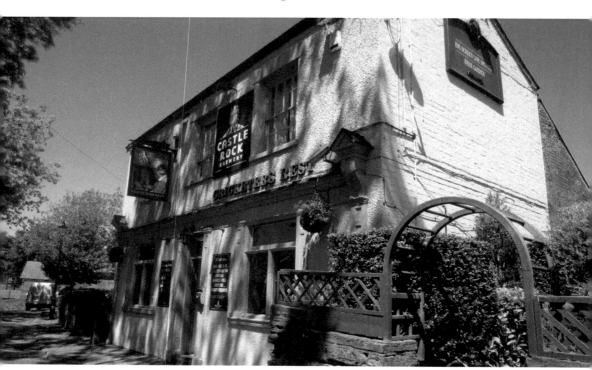

Outside the Cricketers Rest.

A warm welcome for veterans, the Cricketers Rest.

Like many of the pubs in Kimberley, there is a heavy football focus. The landlord is proud that, during big matches, so many people are keen to choose his pub over the others. 'It's the atmosphere,' he assures me.

It's not just football that draws people to the 'Cricks'. Tuesday night is quiz night – with a celebrity quizmaster! TV and radio host Al Needham is there to ask the questions.

On the day that I happened to pop in to get photos for the book, a large military parade had marched through the town. Afterwards, some fellow veterans had joined the landlord for a couple of drinks in the pub. They were all dressed for the occasion with medals presented proudly on their chests. 'This is a pub that attracts a lot of veterans, from all of the services. We get servicemen of all ages.' He pointed out a man who had seen active service in the 1960s and another one who had done his duty in the early '80s. 'On armed forces day, we give 10 per cent discount to both veterans and those who are still serving.'

Outside the pub, they lined up beside each other and mugged for the camera – old squaddies, enjoying a well-deserved drink.

Exit The Cricketers Rest and turn right. The road forks off to the left, down a slight hill. At the bottom of this, continue in the direction that you have been travelling. After a couple of minutes on your right, you should plainly see The Nelson & Railway.

50. The Nelson & Railway
The Burton family having been running The Nelson & Railway since 1970 and Harry Burton has had his name on the licence for all of that time. The day-to-day running, however, has now fallen to his son, Mick.

Inside the Nelson & Railway.

Until the brewery closed, this pub was the tap and its proximity made it a favourite with the draymen coming off shift.

The name of the place has always perplexed people: what does Horatio Nelson have to do with steam trains? The explanation is disappointingly simple. This is two buildings knocked together – The Lord Nelson pub and the Railway Hotel, which served the nearby (and long since closed) station.

The pub still operates as a hotel, with eleven en-suite rooms, largely catering to foreign visitors who want to stay in a traditional pub and to people who come to work locally.

The pub itself is cosy, dark panelled and slightly quaint. It has a warm atmosphere that is perfect for a winter's evening. In summer, you may sit in either the front or rear beer garden. The one at the front is nicer, with a lovely, pastoral feel being provided by the surrounding trees and the lane that runs along the pub's front.

Food is served seven days a week and there are four revolving guest beers on the pumps, as well as the regulars. Quiz nights are on a Sunday and they are always a very lively and well-attended affair. Similarly well attended, the first Thursday of the month is live music night – a showcase for local talent, organised by the people who run the Kimberley Jam.

If you happen to be visiting Nottingham, I would strongly recommend The Nelson as a place to stay.

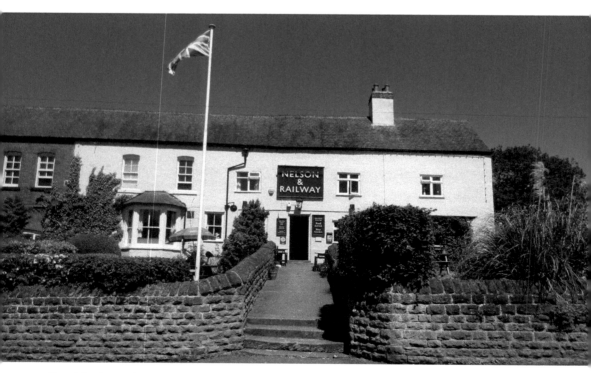

Outside the Nelson & Railway.

This is the formal end of the walk, but you may like to have a quick look around what is left of the brewery. If so, exit The Nelson & Railway by the front door and turn right on the road. After a minute or so, the brewery buildings will be straight in front of you. Turn right here to walk up Hardy Street. From here you can explore what remains of the Kimberley Ales brewery at your leisure.

Kimberley Brewery
in ruins.

Acknowledgements

I would like to thank all of the staff and punters at the various pubs that I have visited in the writing of this book for the patience, help and support that they have offered. I couldn't have written it without them.

I would also like to thank my wife, Sarah, for her advice, suggestions, proofreading and the use of her camera!